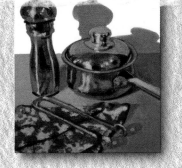

Still Lifes

Painting still lifes is one of the most rewarding artistic activities, as you have complete control over the subject—you decide what objects to paint, where to place them, and how to light the scene. I like to use acrylic for painting still lifes because the bright, vibrant colors seem to pop off the canvas and demand the viewer's attention! You can also produce a wide variety of effects using acrylic—for example, you can dilute the paint for transparent washes of color, or you can build up layers of thick paint for opaque applications. And because this medium dries quickly, you can complete a painting in a short amount of time. Throughout the following lessons,you'll discover the tools and inspiration you need to arrange dynamic setups and express your creativity as you paint your own exciting still lifes in acrylic! —*Nathan Rohlander*

CONTENTS

SELECTING TOOLS AND MATERIALS

Acrylic is often the first medium beginning painters choose—and it's no wonder why. It requires few tools and little expense to get started; all you really need are some basic paint colors, a small assortment of brushes, and a surface on which to paint. These pages will provide a quick overview of the basic materials you'll need to get started, as well as tips on creating a work space and selecting the colors that will make up your palette. For more in-depth information on acrylic painting supplies, refer to *Watercolor & Acrylic Painting Materials* by William F. Powell in the Artist's Library series.

PICKING YOUR PAINTS

Acrylic paints are available in tubes, jars, and cans; they also come in two different types. The highest-quality paints are labeled "artist grade"; they contain more pigment and produce richer, truer colors than do the less expensive "student grade" versions, which contain more filler. But you'll end up using more paint trying to achieve opaque layers of bright color if you're using an inferior grade.

PURCHASING A PALETTE

Palettes for acrylic paints are available in many different materials—from wood and ceramic to metal and glass. Plastic palettes are inexpensive and can be cleaned with soap and water. Disposable paper palette pads are also very convenient; instead of washing away the remains of your paint, you can simply tear off the top sheet to reveal a fresh surface underneath. Whatever you choose, make sure it is easy to clean and large enough for mixing your colors. And it's a good idea to purchase a few palette and painting knives—flat, thin tools used to mix paints on the palette or apply paint to the canvas.

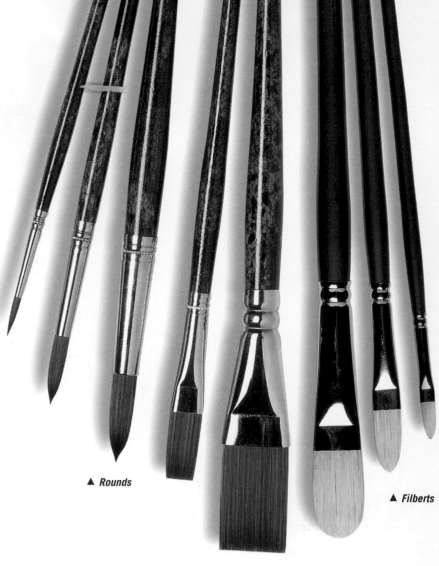

▲ *Rounds*

▲ *Flats*

▲ *Filberts*

▲ **BRUSH BASICS** Each brush has its own shape and purpose. The three basic workhorses are flats, rounds, and filberts—start with a small, medium, and large size of each. The large and medium flats are good for painting washes and filling in large areas of color; the smaller flats are needed for detail work, drybrushing, and making clean, sharp edges. Larger rounds and filberts are useful for sketching outlines and general painting, whereas the smaller sizes are essential for adding intricate details.

BUYING BRUSHES

Brushes are grouped by hair type (soft or stiff and natural or synthetic), style (such as round, flat, or filbert), and size (1" or no. 2, for example). Whether you choose natural or synthetic hair will depend on your working style and on the investment you wish to make. Synthetic hair brushes are a bit less expensive, but both kinds can produce quality work.

SELECTING COLORS

The colors shown at right are a good basic palette for painting still lifes in acrylic. Every artist has unique colors on his or her chosen palette, so the projects in this book will give you the opportunity to try other colors as well. For these lessons, you will need to add one or more of the colors listed below to the recommended basic palette.

- ❏ Cadmium yellow light
- ❏ Cadmium orange
- ❏ Burnt sienna
- ❏ Acra Violet
- ❏ Cadmium red light
- ❏ Chromium oxide green
- ❏ Ultramarine violet
- ❏ Quinacridone crimson
- ❏ Quinacridone green

BASIC PALETTE

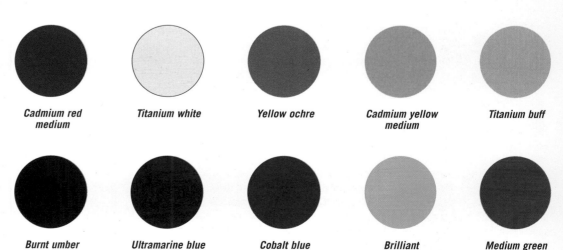

Cadmium red medium	*Titanium white*	*Yellow ochre*	*Cadmium yellow medium*	*Titanium buff*
Burnt umber	*Ultramarine blue*	*Cobalt blue*	*Brilliant yellow-green*	*Medium green*

SETTING UP A WORK SPACE My studio loft is a converted brewery with a lot of natural light. In addition to natural light, it is wise to have artificial light sources for painting at night or on overcast days. It's also a good idea to make sure that your studio has ample storage space and maneuvering room. My palette, mounted on wheels, has a large glass tabletop, providing a surface that is easy to clean; I also have washable rubber pads on the floor to protect my feet. It is important to tailor your work space to your needs, as it makes your painting experience much more enjoyable.

Primed hardwood panel (rough side)

Primed hardwood panel (smooth side)

Illustration board

Canvas

SELECTING SURFACE TYPES The type of surface on which you paint—from silky smooth to grainy or rough—determines the textures of your brushwork. The examples above show how thick (left) and thin (right) washes of acrylic paint look when applied to four varying types of surfaces, including hardwood panel, illustration board, and canvas.

CHOOSING YOUR SUPPORTS

By perusing the aisles of your local art supply store, you'll find a wide variety of painting surfaces—often called "supports"—that will accept acrylic paint. Ready-made canvases are available in dozens of sizes and come preprimed (coated to make them less porous) and either stretched on a frame or glued over a board. Watercolor or illustration boards also work well with acrylic paint, providing a smoother surface. (See the samples above right.) Experiment with several different kinds of supports to see which best suits the needs of your own painting style.

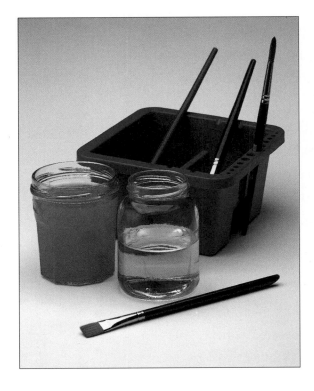

◄ CARING FOR YOUR BRUSHES Be careful to never let acrylic paint dry in the brushes, as it will ruin them. When you are finished painting for the day, remember to wash your brushes in tepid water (never hot) and lie them flat or hang them bristle-down to dry.

MEDIUMS

Because acrylic is water based, you can thin it simply by adding water. But water is not the only substance you can add to your acrylic paint to alter its consistency. There are a variety of acrylic mediums available that achieve a range effects—from thin, glossy layers to thick, impasto strokes. In the projects in this book, I use only acrylic retarder, but it's a good idea to get to know all your options.

Varnish

Retarder Glaze

Retarder to slow drying

Gloss medium is a watery fluid that thins the paint while giving it a shiny surface when dry. In contrast, *matte* medium causes the paint to dry to a satiny sheen. *Gel* medium has more body than gloss or matte mediums, giving the paint a heavier consistency for thick strokes. *Texture* mediums are even thicker, and they turn the paint into a paste. Texture mediums come in different types, such as sand and fiber. *Varnish* coats the surface of a painting with a hard, glossy, transparent film. *Retarding* medium helps slow the drying time of the paints; it can also be added to paints as a thinner to create quick-drying glazes. (See page 6.) *Flow improver* increases the fluidity of paint and eliminates brush marks within strokes. Although these mediums may at first appear milky or opaque, most dry clear or almost clear.

ADDING TO THE BASICS

Before getting started, you'll want to have a few extra items on hand. Paper towels or lint-free rags are great to have when painting—you can use them to clean your tools and brushes, and you can also employ them as painting tools to scrub in washes or soften edges. It's also a good idea to have two jars of water: one for diluting your paints, and one for rinsing out your brushes. While you're working, it's important to keep your paints moist because acrylic paints dry quickly; a spray bottle filled with water will help keep the paints and mixes on your palette fresh. Another way to keep your paint moist is by adding acrylic retarder (see box at left); I never use more than a 15% solution, though, because too much retarder can cause uneven drying. Household items can be used as straightedges, but rulers are great to have handy as well. A roll of masking tape or artist's tape is another useful tool for creating straight edges or for masking. (See page 7 for more information on masking.)

Understanding Color Theory

The color wheel is a circular diagram of the spectrum of colors, demonstrating relationships among colors. Yellow, red, and blue are the three main colors of the wheel. These *primary colors* are the basis for all other colors on the wheel, and they can't be created by mixing any other colors. When two primary colors are combined, they produce a *secondary* color—green, orange, or purple. And when a primary and a secondary color are mixed, they produce a *tertiary* color, such as blue-green or red-orange. Colors directly opposite one another on the wheel—like yellow and purple or orange and blue—are called "complements." When paired, complementary colors create striking contrasts. Groups of colors that are adjacent on the color wheel—such as green, blue-green, and blue—are referred to as "analogous." Because analogous colors are similar, they create a sense of unity or harmony when used together in a painting.

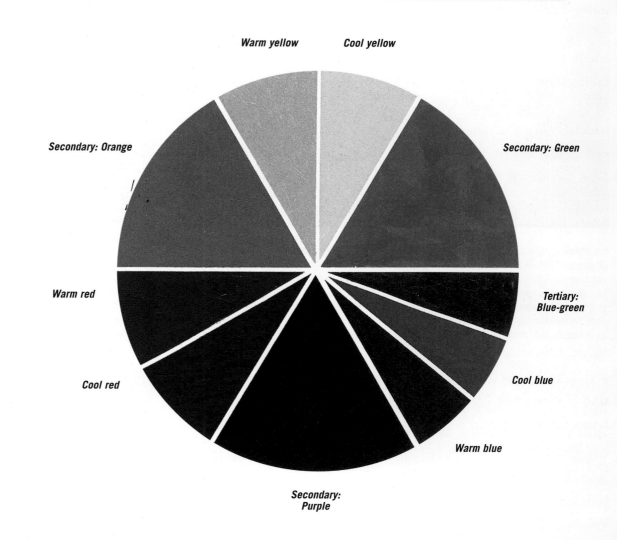

THE COLOR WHEEL This convenient visual aid helps you immediately identify primary, secondary, and tertiary colors, as well as complementary and analogous colors. Knowing the basics of how colors relate to one another will help you create different moods—and develop interest and harmony—in your paintings.

EXPLORING COLOR "TEMPERATURE"

Colors are also identified by their "temperature"; that is, colors are defined as being either "warm" or "cool," and each color conveys a mood that corresponds with its temperature. Warm colors—such as reds, oranges, and yellows—tend to "pop," or advance forward in a painting, suggesting excitement and energy. On the other hand, cool colors—blues, greens, and purples—appear to recede, making them an optimal choice for creating a sense of serenity or peacefulness. Color temperature can also communicate time of day or season: Warm colors correspond with summer and late afternoons, whereas cool colors are reminiscent of winter and early mornings.

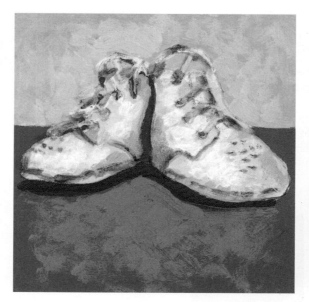

WARM TONES Here I've applied warm washes of cadmium orange and cadmium yellow medium, shading the shoes with cadmium red medium and the foreground with a mixture of cadmium orange and titanium white. By referring to the color wheel, you can see that I've chosen to use all the colors from the "warm" side of the wheel—reds, oranges, and yellows. These colors produce a sense of warmth and comfort, as if the shoes were basking in a ray of sunlight or in front of a crackling fire.

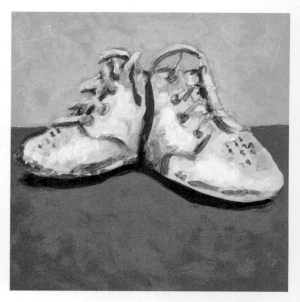

COOL TONES To the same drawing, I've applied colors found on the "cool" side of the color wheel. In contrast to the warm painting, the violets and blues suggest a relaxed, serene composition, which evokes a sense of reflection and quietude. While colors are generally thought of as being "cool" or "warm," each color also has warm and cool versions, as shown on the color wheel above. For example, a red with a little more blue in it will appear cooler than one with more yellow.

MIXING NEUTRALS

Because pure paint color from the tube doesn't resemble most colors in nature, it is important to learn how to mix your own natural-looking colors. Dynamic neutral colors (browns and grays) can be created using two different methods: you can mix together two complementary colors—such as green and red; or you can try combining the three primary colors—blue, red, and yellow. When mixed, complementary colors "gray" one another, resulting in a neutral color. The same effect is achieved when mixing primary colors. This is a good technique to use when you want to give your painting more variation and life, as blended neutrals aren't as flat as paints that come straight from the tube. And by altering the quantity of each color in your mix or by using differing shades of primaries, you can create a range of colors to match almost any subject.

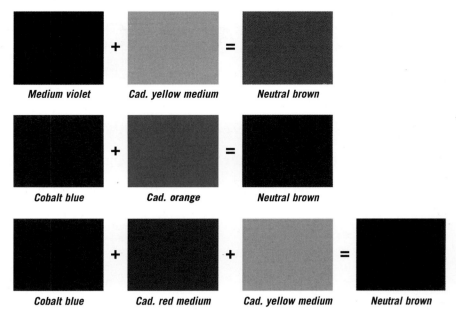

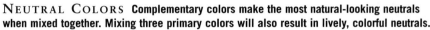

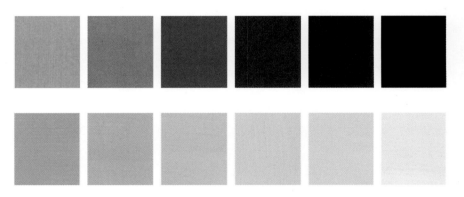

NEUTRAL COLORS Complementary colors make the most natural-looking neutrals when mixed together. Mixing three primary colors will also result in lively, colorful neutrals.

CREATING VALUES

Value, defined as the lightness or darkness of a color (or of black), and its variations throughout a painting are key to creating the illusion of dimension. To expand my range of colors, I can create different values of the colors using my basic palette. Adding white to a color results in a *tint* (a lighter value of the color), whereas adding black to a color produces a *shade* (a darker value of the color). By simply mixing varying amounts of white or black into your colors, you can create a wide array of tints and shades, which can add greater degrees of interest, depth, and dimension to your paintings!

VALUE SCALES Creating value scales like the ones above will help you get a feel for the range of lights and darks you can create with different variations of color. The top row represents *shading*, where black is applied to pure color (cadmium yellow medium) to create darker values. In contrast, the bottom row shows *tinting*, where white is added to pure color (brilliant yellow-green) to create lighter values.

APPLYING AN UNDERPAINTING

Although there are countless ways to approach a blank canvas, many artists start by *toning* the support, or covering it with a thin wash of color. This technique is called "underpainting." The initial layer of paint serves as a base or foundation to build colors on, and it is sometimes allowed to show through in areas of the final painting for interest and variation. Using a toned support ensures against "holes" in the final piece—or places in the painting that somehow were accidentally left unpainted. As the tone of the canvas will generally reflect the mood and atmosphere of the final painting, it is very important to decide whether you want to use warm or cool colors. If you are trying to render a bright, vibrant painting whose colors seem to pop off the page, choose a warm tone for your underpainting. If you want to convey a feeling of serenity, opt for cooler tones. Most artists select fairly neutral colors for toning the support—warm colors serve as good foundations for earth-toned subjects, whereas blue and other cool colors suit most other subjects.

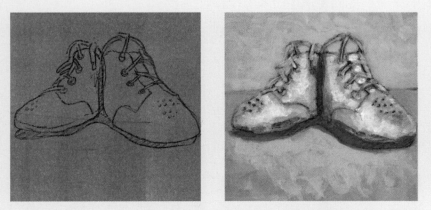

COOL UNDERPAINTING Here I cover the canvas with a diluted application of blue and then sketch my subject. I purposely leave some areas unpainted, letting the serene blue tones peek through. This blue undertone will also have an effect on all the colors later applied to the painting, resulting in a composition with a mellow and calm ambience.

WARM UNDERPAINTING By applying a very diluted wash of red, I create a warm tone for my underpainting. I paint the scene with the same colors used in the example to the left, but the underpainting's red color produces a different effect. The warm underpainting influences subsequent layers of color to give the painting a cheerful, vibrant feeling.

PRACTICING TECHNIQUES

There are myriad techniques and tools that can be used with acrylic paint to create a variety of textures and effects. From toning your support with a wash of diluted paint (see "Applying an Underpainting" on page 5) to building up gradual layers of paint by applying successive *glazes*—or very thin mixtures of diluted pigment—to your support, the possibilities are endless! And whether you're removing color with a moist tissue or adding thick applications of paint with your painting knife, you can create any texture—from the rough, braided exterior of a basket to the smooth, reflective surface of glass. You can also use different brushstrokes to add special effects to your paintings; for example, broad, angular slashes will render sharp edges, whereas light, dabbing strokes with thin paint will achieve a soft look. And additional tools—a knife, a rag, a sponge, and even your finger—can be used to create texture and interest. By employing some of these different techniques, you can spice up your art and keep the painting process fresh, exciting, and fun!

FLAT WASH A *wash*—a thin mixture of paint that has been diluted with water—is generally used to quickly cover large areas with color. First load a flat brush with diluted paint; then tilt the canvas as you lightly sweep overlapping, horizontal strokes across the support. This technique is good for underpainting and filling large shapes.

GRADED WASH Create a *graded wash* when you want the color to fade from dark to light. Stroke diluted paint horizontally along the top of the surface with a flat brush. Work your way to the bottom, adding more water and less pigment as you lighten the color gradually. Graded washes are great for creating interesting backgrounds.

DRYBRUSH *Drybrushing* creates texture. Use a worn, scruffy flat or fan brush, load it with thick paint, wipe it on a paper towel to remove moisture, and then apply it to the surface using quick, light, irregular brushstrokes. This technique is useful for creating the look of natural items, such as wood, rope, fruit rinds, and fibers.

SAVE TIME—PLAN AHEAD!

Acrylic is a great medium for beginning artists because it dries quickly, which makes it easy to "correct" mistakes. If you want to change the color or composition of your piece, you can simply paint over already-dried paint. But it's always a good idea to try to avoid errors when possible, and some can be prevented by taking simple precautions from the very beginning. Taking an extra moment to prepare before and while you paint will ensure successful results and will save you time in the long run. For example, sketch out your subject before you begin painting to make sure that the sizes, shapes, and proportions are to your liking. Remember that, as an artist, you are free to get as creative as you want—not all paintings have to be symmetrical and evenly proportioned; some of the best aren't! But what matters most is that the composition and placement of elements in the painting are pleasing to you, so take time to think things out before delving into your acrylic adventure. It's also important to keep tools on hand that might be helpful, like a ruler, artist's triangle, or straightedge that can be used as a guide. And be sure to have paper towels and lint-free rags handy, as well as an ample supply of water for rinsing, diluting, and cleaning up. Planning ahead will not only ultimately save you time, but it will also ensure that your painting experience goes as smoothly and effectively as possible.

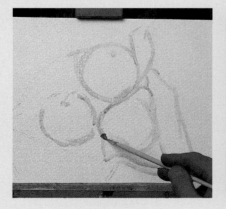

SKETCHING YOUR SUBJECT Draw a simple, rough sketch as a guide for your painting. Light pencil is effective, but thinned paint and a small round brush work as well. Then you can wipe off any errors or unwanted lines before you begin painting.

TAKING PRECAUTIONS Planning ahead means not leaving things to chance. If your subject requires a perfectly straight line, you can paint against a plastic ruler, a thick sheet of paper, or a strip of masking tape.

THICK ON THIN Stroking a thick application of paint over a thin wash produces textured color variances. Apply a wash for the foundation color; then paint thickly on top, letting the undercolor peek through in spots. This technique is perfect for rendering rough or worn surfaces, such as old buildings and walls.

DRY ON WET Painting *"dry on wet"*—or applying dry paint to a damp surface—also gives a painting texture. First create a heavily diluted wash of paint and apply it to your support. Then, before the paint has dried, dip a dry brush in a second color and stroke quickly over the underpainting. This is great for producing a grainy, woodlike look.

IMPASTO The *impasto* technique is a method of painting thickly. Use a paintbrush or a painting knife to apply thick, varied strokes, creating ridges of paint. This technique produces a buttery texture, adding dimension and texture to the paint itself; it's also good for punctuating highlights in a painting.

SCUMBLE *Scumbling* is the technique of painting near-transparent colors over already-dry paint. With a dry brush, lightly scrub semi-opaque color over dry paint, allowing the underlying colors to show through. This is an excellent technique for conveying depth and distance in a painting, especially when rendering backgrounds.

STIPPLE *Stippling* is applying a series of small, clustered dots to create texture. Use a stiff bristle brush and hold it very straight, bristle-side down. Then dab on the color quickly, in short, circular motions. This technique is often used to create the illusion of reflections or highlights in a painting.

SCRAPE *Scraping* is a method of scratching off layers of wet paint, allowing the underpainting to show through. Using the side of a palette or painting knife, create grooves and indentations of various shapes and sizes. This works wonderfully for creating rough textures such as wooden tabletops.

GLAZE *Glazing* is the building up of thin layers of color to add interest and dimension to a painting. Apply thin, diluted layers of transparent color over existing dry color. Let the paint dry between each layer. The glazed color will visually blend with the colors underneath. Glazes are especially useful for rendering shadows and reflections.

MASK WITH TAPE Masking tape can be placed onto and removed from dried acrylic paint without damaging an existing layer. This makes it easy to produce a sharp edge. Make sure the edges of the tape are stuck down firmly and don't paint too thickly on the edges, otherwise you won't get a clean line when you lift off the tape.

LIFTING OUT Artists sometimes "lift out" color to lighten a wash or remove color. While a wash is damp, use a moistened brush or a tissue to press down on the support and lift out the desired colors. If the wash is dry, moisten the area of color with water or a flat brush; then blot the paint with a clean paper towel.

COMPOSING THE SUBJECT

The most fundamental element of painting a still life is to create a pleasing *composition*, or the organization of the elements of a painting. A good composition leads the viewer's eye around the lines, colors, and shapes of the painting and toward the center of interest, or the *focal point*. When setting up a still life, make sure that the focal point is not situated directly in the middle of the setup; by placing the focal point slightly off center, you can create a piece that is much more dynamic and pleasing to the eye. (See page 11.) In this tea set arrangement, I deliberately placed the teapot to the right of the center, allowing the eye to travel along a triangular path—from the colorful placemat to the teacups and finally to the teapot.

LIGHTING THE COMPOSITION

The arrangement of your subjects is an important aspect of a painting, but light and shadow are also keys to a successful composition. Light, medium, and dark values can help lead the eye in and around the composition. Test out different angles and intensities of light to find a pattern of light and shadow that creates a path for the eye to follow, directing it toward the center of interest. In this painting, the strong lighting spotlights the left side of the cups and teapot—leading the eye up into the painting. The strategically placed shadows also prevent the eye from following the teapot off the page.

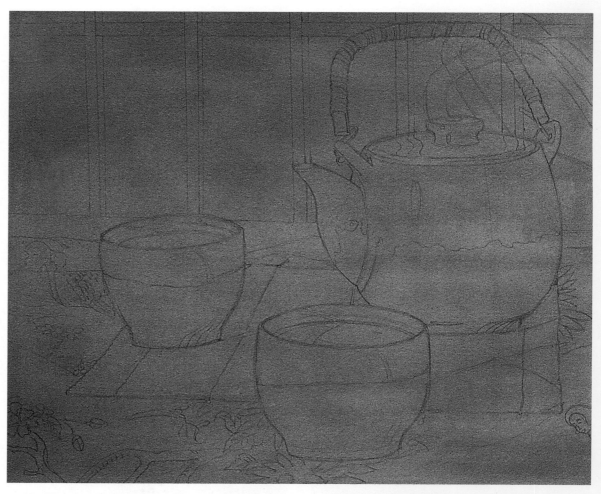

1 I begin by applying an even wash of water-diluted burnt sienna to the canvas with a large flat brush. When the underpainting is dry, I sketch in my composition with a pencil, placing the objects slightly off center. I also indicate the shadows cast by the teapot handles and the rough outline of the patterns on the tea set, wall, and tablecloth.

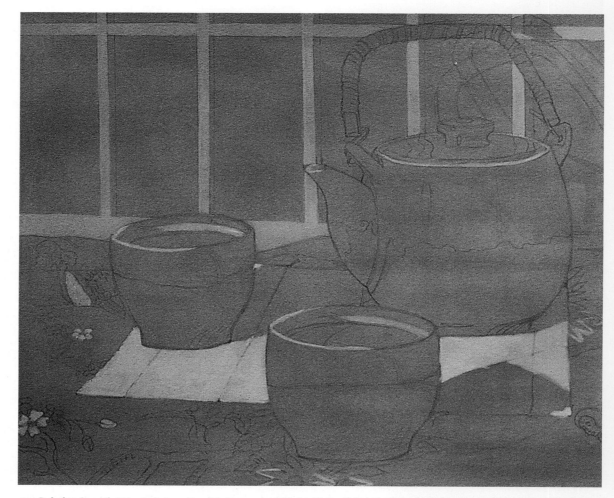

2 Painting from light to dark (see the detail on page 10), I add the lightest values to the sketch. I apply a mix of yellow ochre and titanium buff to the rims of the teacups, the spout and rim of the teapot, the flowers of the tablecloth, and the lightest parts of the placemat. Then I blend yellow ochre with titanium white to begin creating the bamboo grids on the wall.

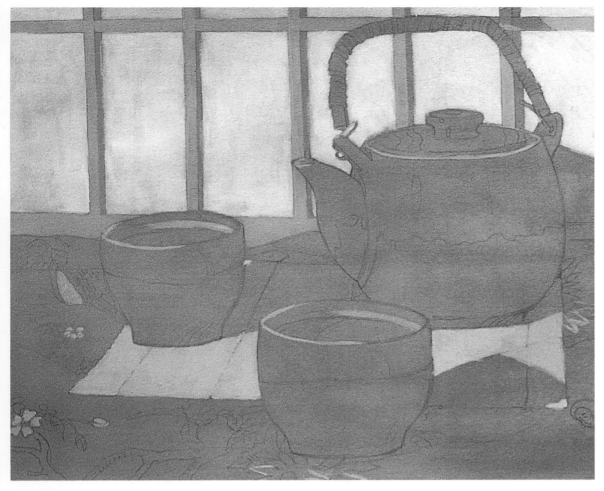

TEA SET HIGHLIGHTS
Yellow ochre + titanium buff

LIGHT BACKGROUND VALUES
Titanium white + ultramarine violet + acra violet

SHADOW HIGHLIGHTS
Titanium white + ultramarine violet + acra violet + ultramarine blue

SHADOW MIDTONES
Titanium buff + burnt umber

3 Switching to a medium flat brush, I build up the background by painting the *negative spaces* (see "Painting Negative Space" on page 10) with a mixture of titanium white, ultramarine violet, and acra violet. Then, using a small round brush, I apply additional layers of titanium white mixed with yellow ochre to bring out the color of the bamboo grids.

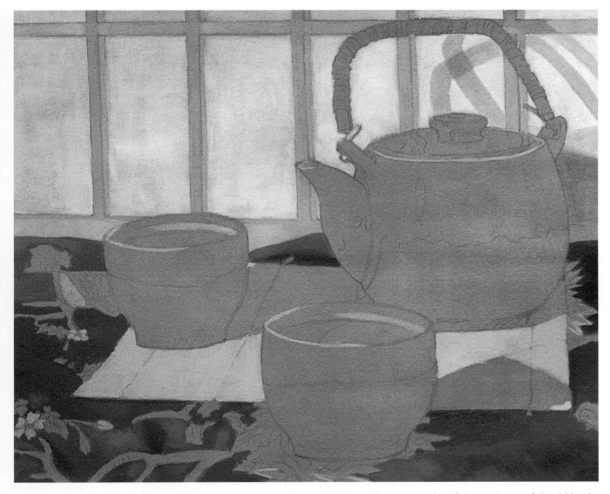

TABLECLOTH MIDTONES
Cadmium red light + acra violet

TABLECLOTH DARKS
Cadmium red light + acra violet + burnt umber

TABLECLOTH PATTERN DARKS
Burnt umber + yellow ochre

4 After continuing to build up the background with variations of titanium white, ultramarine violet, and acra violet, I blend light and dark values of the same mixture (see page 5) for the cast shadows of the teapot handles. I quickly and loosely block in the reds of the tablecloth, still using a medium flat brush but with a mixture of cadmium red light and acra violet.

PAINTING NEGATIVE SPACE *Negative space is* the empty space between objects or the parts of objects. (The actual objects are the "positive space.") In this painting, one example of negative space is the area between the bamboo grids on the wall. If an object appears to be too complex or if you are having trouble "seeing" it, try focusing on the negative space instead. You can do this by squinting your eyes, which blurs the details so that you can only see the negative and positive spaces. You'll find that when you draw the negative shapes around an object, you're also creating the edges of the object itself!

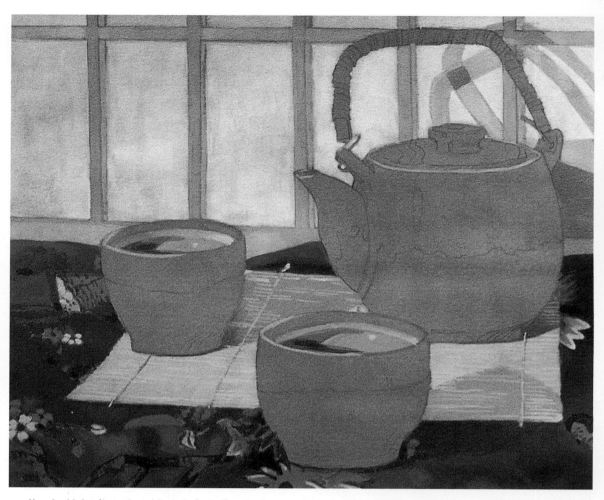

5 Now I add details to the tablecloth, including the flowers, the branches, and the small face in the right-hand corner. I also bring out the pattern of the placemat by applying vertical strokes of titanium buff mixed with yellow ochre. I use titanium buff with hints of yellow ochre for the tea, and then I add shadows inside the teacups by applying titanium buff mixed with burnt umber and a little ultramarine blue. Using very faint dabs of titanium white, I add highlights to the tea, and I also lighten the cast shadows of the teapot handles.

WORKING FROM LIGHT TO DARK I break my subject down visually into three categories: dark values, mid-range values, and highlights. Then I establish these values in layers, painting from light to dark. Here, in the tablecloth, I first apply the lighter values of the branches and flowers, and I build up the darkest values—the reds—of the floral pattern last.

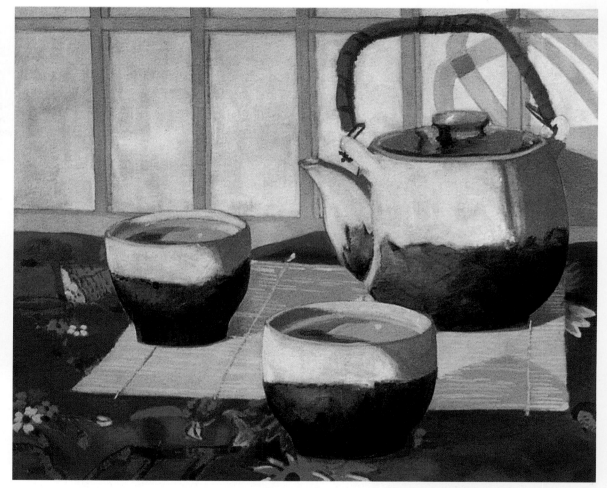

6 Using burnt umber mixed with ultramarine blue, I paint the dark areas of the teacups and teapot. I add water to this mixture to create the lighter values of the dark blue, giving dimension to the tea set. Next I use a mixture of titanium white and ultramarine blue for the light areas of the tea set, and I apply burnt umber to the handle of the teapot to darken it. With a small round brush, I intensify the shadows of the teacups with darker values of the yellow ochre and titanium buff mixture, also applying yellow ochre to emphasize the reflections in the tea.

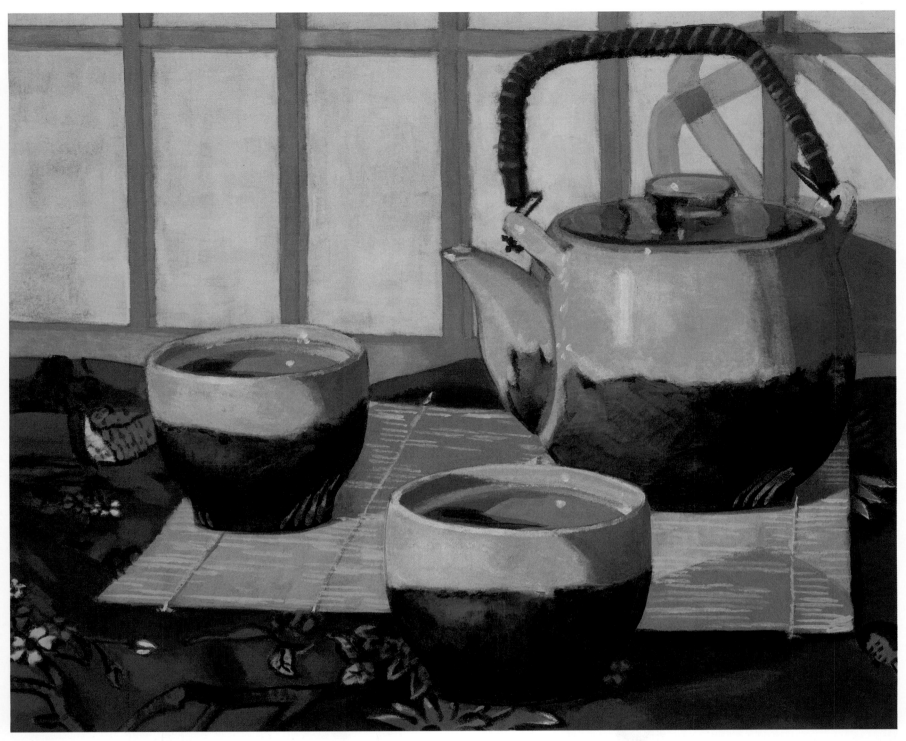

7 Finally I use a clean, dry, flat brush to blend and smooth out the transitions between colors. Then I bring out the highlights in the teapot and teacups and touch up the highlights in the lightest values of the tablecloth using titanium white. Next I use burnt umber to outline and refine the darkest values of the painting, including the dark areas of the tea and the branches on the floral pattern of the tablecloth. This technique of emphasizing my lights and darks ensures high contrasts of values for dramatic effect. I take one last look at the painting as a whole, making sure that the final values of the composition lead the eye on a path straight to the focal point. And then my painting is complete!

CREATING A VISUAL PATH

By planning the visual path that the objects in your composition will create ahead of time, you can help to ensure that your painting will be successful. I often place objects in diagonal lines to lead the viewer's eye around the painting, and I avoid evenly spacing objects in a row, as horizontal lines tend to lead the eye out of the picture. I also make the objects relate to one another by overlapping them and staggering them on different planes.

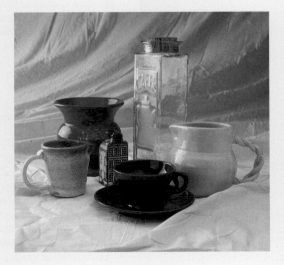

◄ GOOD SETUP
The still life setup to the left shows a good balance of elements of varying shapes and sizes. It also shows effective use of spatial planes and diagonal lines. The objects are overlapping one another, creating a dynamic composition that draws the viewer's eye in and around the painting.

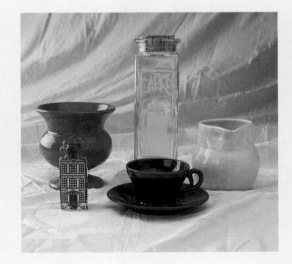

◄ POOR SETUP
This setup is an example of a poorly placed composition, with unimaginative lines and dull viewing angles. The objects are evenly spaced from one another, creating a horizontal line. And because the objects in this setup aren't placed at differing angles, the objects have no relation to one another.

WORKING FROM PHOTOGRAPHS

While painting a still life composition from an actual setup can be rewarding, there are times when using a photograph instead can be helpful. Photos allow you the luxury of experimenting with different setups; when you find one that pleases you, you have a permanent record of the setup to use as a reference. And having a permanent reference means you don't have to hurry the painting process; for example, if you want to paint a little each day rather than completing your work in one sitting, there's no need to worry about wilting flowers or—as was the case with this photographed setup—aging fruit!

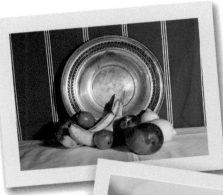

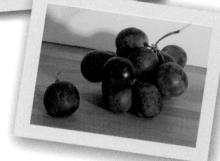

◄ COMBINING ELEMENTS
After photographing my initial setup, I decided to add a cluster of grapes to make my composition a little more dynamic and balanced in terms of color. I took several photographs of grapes and compared them to my original photo. With a little effort, I was able to combine the two elements. When combining photos, be careful to keep the proportions correct and the light source consistent.

1 First I use a large flat brush to apply an even underpainting of water-diluted burnt sienna. After the paint is dry, I sketch the composition of the scene with a pencil, using my reference photos for accuracy. After sketching the fruit and silver bowl, I add the cluster of grapes to the left of center to create more visual interest.

2 With titanium white paint, I color the whites of the background stripes and the tablecloth. I fill the negative space with thick applications of cadmium red medium, using a medium flat brush. Next I begin work on the shadows, adding hints of ultramarine blue and burnt umber to a mix of burnt sienna, cadmium red medium, and titanium white.

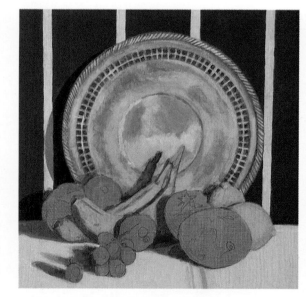

3 Now I begin detailing the bowl. First I simplify the shadows and highlights into basic shapes, creating a pattern of reflections. For the metal, I apply a mixture of titanium white, burnt umber, and ultramarine blue. I switch brushes and brushstrokes when painting the bowl to add variation. Then, using titanium white, I add dramatic highlights, finally bringing in some yellow ochre to give the metal an antiquated look.

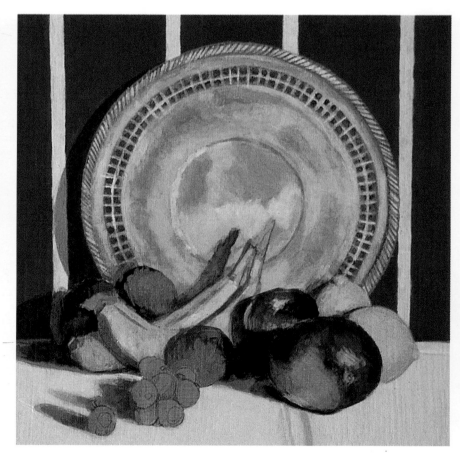

4 I begin developing the shadows of the fruit by blocking in their shapes, but I am careful to soften them around the edges. Next I begin painting the fruit: I use cadmium yellow medium, yellow ochre, burnt umber, and titanium white to paint the bananas and lemons. Then I apply a mixture of quinacridone crimson, cadmium red medium, burnt sienna, cadmium yellow medium, ultramarine blue, and burnt umber to the nectarines. For the limes, I mix brilliant yellow-green, medium green, and ultramarine blue; and for the grapes, I apply quinacridone crimson, cadmium red medium, ultramarine blue, burnt umber, burnt sienna, and titanium white. I paint the mango with a mixture of cadmium red medium, cadmium yellow medium, medium green, ultramarine blue, and titanium white.

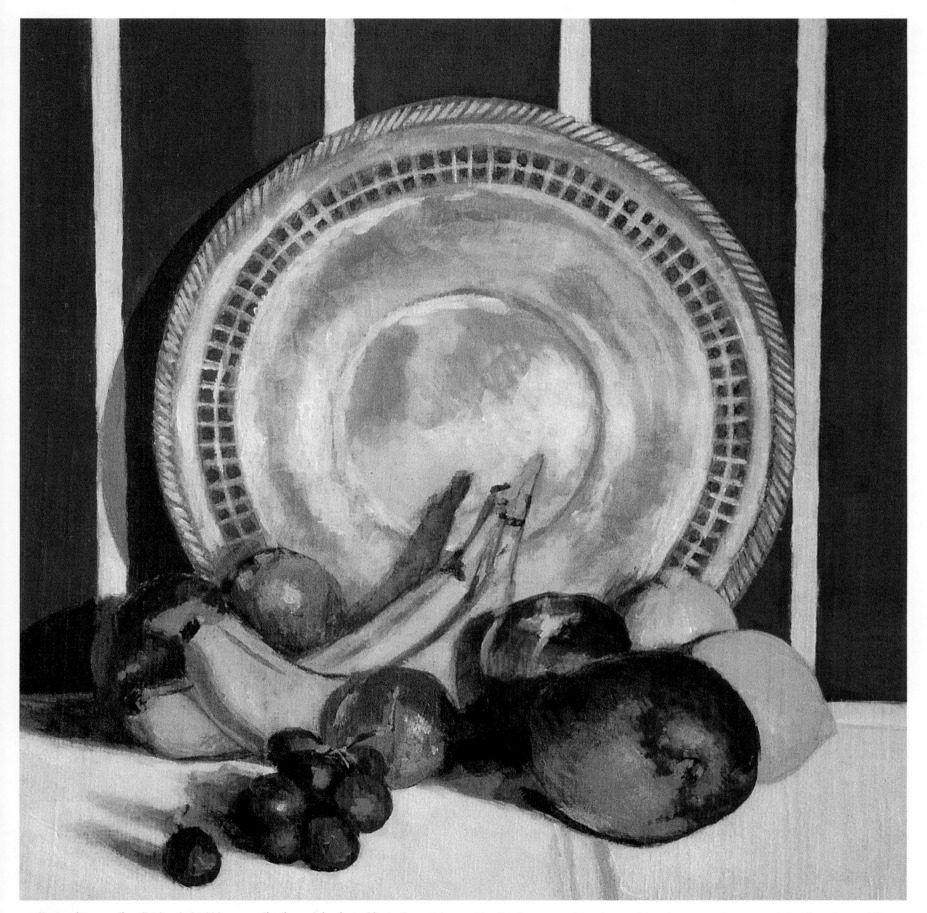

5 Next, using a medium flat brush, I add loose applications of titanium white to the metal bowl, emphasizing the lightest areas. I want to show that the light source is coming from above, so I add quick strokes of titanium white to the upper halves of the surface of each piece of fruit. Then, using the edge of a small round brush, I finalize the mango, grapes, and limes, and I apply darker values to the shadows of the fruit and bowl. I am careful to maintain the crisp separations between the colors of each fruit, making sure that my blending is not smoothing the transitions between paints so much that the colors and lines become blurred. When I'm finished, I use my detail brush to trace along the edges of the fruit and clean up the outlines, sharpening the realistic qualities of the painting. Then I add final details to the stems of each fruit, paying close attention to the mango, as it is in the foreground of the composition and thus has the most detail. Finally I strengthen the darkest values of the painting, making the most of the play between light and shadow in the setup.

CHOOSING A SUBJECT

Deciding what to paint is one of the most exciting parts of the creative process, as it allows you to express your own personal style. When choosing a subject for a still life, you don't have to limit yourself to traditional subjects, such as a bouquet of flowers or a bowl of fruit. You can capture the beauty of anything in a still life, from a pile of firewood stacked against an old fence to a squashed aluminum can or a broken television set. Study the lines, shapes, and colors in objects that may strike you as interesting or different. Soon you'll be seeing potential still lifes in everything from piles of laundry to crumpled papers in a wastebin. Sometimes it's the last still life setup that you would expect to see that is the most innovative! With this painting, I chose to focus on the contrast of a rich burgundy pair of shoes against a bright red chest of drawers, creating a unique study in color from what would otherwise seem like nothing more than a painting of pair of shoes on the floor.

◄ STARTING WITH A SKETCH When setting up a composition, some artists make quick, rough sketches to establish the basic shapes of a setup. But I prefer to take my time to carefully duplicate the details of this scene, paying attention to changes in value so as to provide a "map" for the subsequent layers of color.

1 After transferring my sketch to the canvas, I create an underpainting with a large brush and an evenly distributed, very thin wash of ultramarine blue. Then I carefully block in the shapes of the shadows cast by the shoes and the umbrellas with a deeper, more dramatic layer of ultramarine blue.

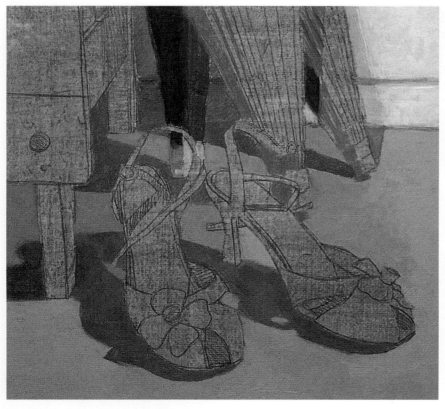

2 Mixing ultramarine blue, burnt umber, and titanium white, I paint the carpet with a medium flat brush. I blend light and dark values of the resulting gray and use retarder to slow the drying time of the paint. With the darkest grays, I block in the shadows cast by the shoes, the umbrellas, and the chest of drawers onto the carpet. Then I build up the shadows of the umbrellas by mixing burnt umber and titanium buff.

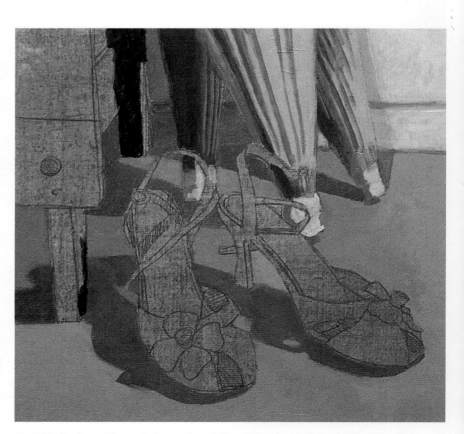

3 With titanium white, cadmium yellow light, and titanium buff, I paint the umbrellas, stroking downward with my brush to create the folds of the material. I then apply a mixture of burnt umber and titanium white to emphasize the folds, and I thickly paint the tips of the umbrellas with pure titanium white. I bring out the darkest values of the shadows, carefully leaving the appropriate spaces unpainted to show the light source coming from above.

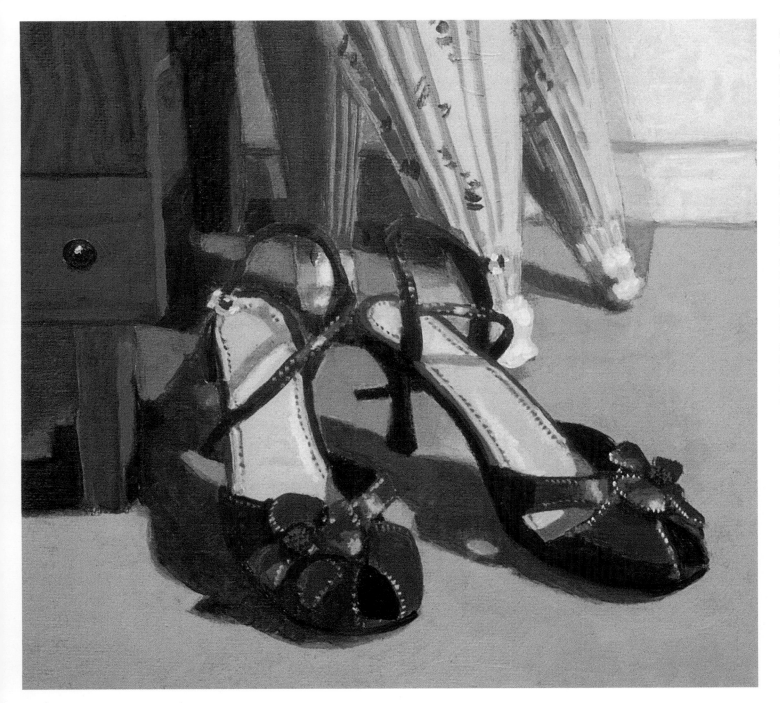

6 Finally I add hints of titanium white to the deep burgundy, again indicating the direction of the light source. I then use a detail brush to apply small dots of a lighter value of the mixture of quinacridone crimson, cadmium red medium, and burnt sienna along the edges of the soles of the shoe. With the same brush, I switch to pure white and apply small dots along the edges of the shoes and their straps. Then, using cadmium red medium mixed with titanium white and a few dabs of burnt umber and burnt sienna, I suggest a floral pattern on the umbrellas. I continue to darken the shadows and bring out the highlights of the painting until I am satisfied with the contrast of color in the composition.

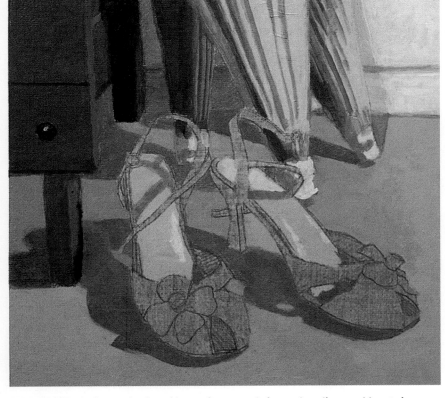

4 Next, with a mixture of quinacridone crimson, cadmium red medium, and burnt sienna, I paint the chest of drawers. I mix quinacridone crimson and ultramarine blue to create the shadows of the wood, and switch to burnt sienna for the knob. I paint the insoles of the shoes with a mix of cadmium red medium and titanium white, adding red to the white in small increments to create the soft pink color. I highlight the shoes with dabs of pure white.

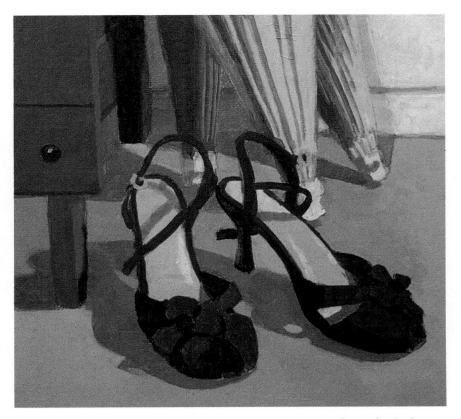

5 Now I block in the burgundy color of the shoes and shoe straps using a mix of quinacridone crimson, cadmium red medium, and burnt sienna. For the shadows, I add more quinacridone crimson to the previous mixture. With a small round brush, I outline the floral shapes of the shoes using darker values of quinacridone crimson, cadmium red medium, and burnt sienna, being careful to ensure that the flowers retain their crisp shape and form.

PORTRAYING GLASS

Although rendering glass might seem like a challenge, its transparent and reflective qualities make it a fun and interesting subject to paint. Glass both reflects light and allows light to travel through it, creating vivid highlights and fascinating translucent effects. And by including both colored and clear glass in the same composition, you can infuse your painting with a wide range of exciting visuals. For this wine and cheese setup, I incorporated reflective and dull surfaces—the gleaming, sparkling wine bottle and glass contrast with the matte exteriors of the mango and cheese—making an eye-catching composition.

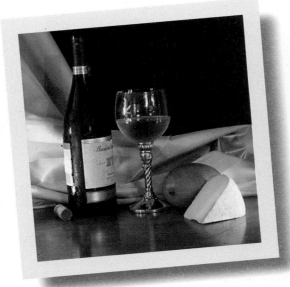

◄ USING DARK BACKGROUNDS
When painting complex forms and symmetrical objects like these, it is a good idea to use a dark background with a strong light source. This creates bright highlights that help the subjects stand out, so they don't blend into their surroundings.

1 First I use a large flat brush to tone the canvas with an even wash of ultramarine blue. Then I sketch the scene with a pencil, carefully mapping out the reflections and highlights on the wine glass, the wine bottle, and the wooden tabletop.

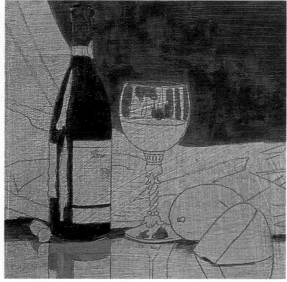

2 Next I paint the background using a mix of ultramarine blue, burnt umber, and titanium white. I use a mixture of quinacridone crimson, burnt umber, and ultramarine blue for the wine bottle; burnt sienna for the neck of the bottle and parts of the table; and yellow ochre for the reflections.

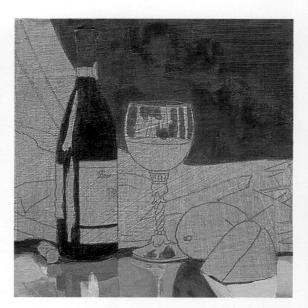

3 Using titanium white and burnt sienna, I block in the wooden tabletop, adding a little yellow ochre, cadmium red medium, and ultramarine blue to create the reflections. Using acrylic retarder while blending helps to keep my paints wet and smooths the color transitions.

WINE BOTTLE HIGHLIGHTS
Brilliant yellow-green + cobalt blue + titanium white + cadmium yellow light + burnt umber + ultramarine blue

DARK BACKGROUND VALUES
Ultramarine blue + quinacridone green + burnt umber + burnt sienna + yellow ochre

WINE AND CHEESE HIGHLIGHTS
Titanium white + cadmium yellow light

TABLETOP MIDTONES
Titanium white + burnt sienna

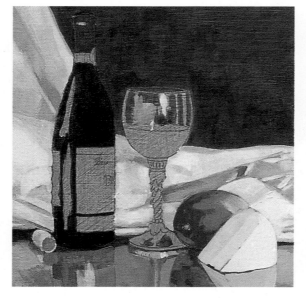

4 For the fabric, I use a mixture of titanium white, brilliant yellow-green, and cobalt blue. Then I mix cadmium red medium with cadmium yellow light for the mango, and titanium white with yellow ochre for the cheese. I apply ultramarine blue to build up the reflections in the glass.

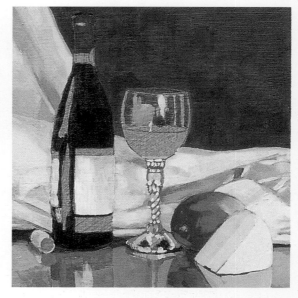

5 With a mixture of ultramarine blue, burnt umber, and titanium white, I paint the stem of the wine glass, applying small touches of titanium white to show the fabric behind the glass. Next I paint the label of the wine bottle with a thick application of titanium white.

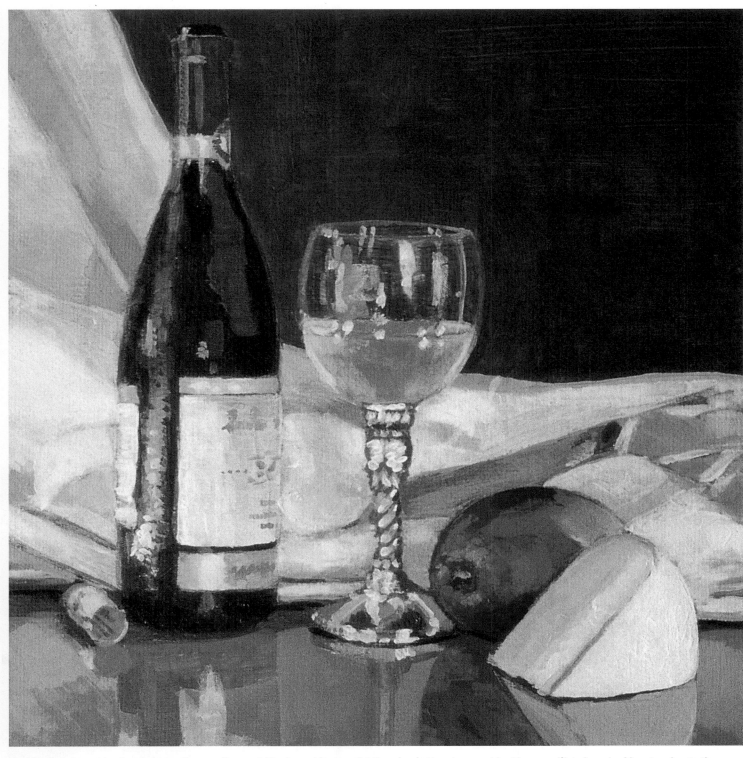

LIGHT FABRIC VALUES
Brilliant yellow-green + cobalt blue + titanium white

LABEL MIDTONES
Cadmium red medium + burnt sienna + titanium white + yellow ochre

LABEL DARKS
Ultramarine blue + quinacridone green + burnt umber

SHADOW VALUES
Ultramarine blue + quinacridone green + burnt umber + burnt sienna

6 Finally I use a mix of cadmium yellow medium and titanium white to paint the wine in the glass, and I add a very diluted wash of burnt umber to the center of the glass to suggest depth. After the paint has dried, I refine the label on the bottle with heavier applications of cadmium yellow medium mixed with titanium white. I lightly suggest the lettering of the label using a small detail brush and variations of the following mixtures: ultramarine blue, quinacridone green, and burnt umber; and cadmium red medium, burnt sienna, titanium white, and yellow ochre. To build up the color of the cheese, I mix titanium white with cadmium yellow medium; then I add lighter values to the wine glass, fabric, and table to sharpen the focus and highlight the subjects.

DETAIL

◄ RENDERING REFLECTIONS
I paint the reflections on the wooden tabletop a little more loosely and with less detail; this is because the reflection of an object on a tabletop isn't as distinct as it would be in a mirror. I then load the brush and pull the color down from the reflected area. I maintain the symmetry, making sure the shapes of the reflections are consistent with the shapes of the bottle and glass.

FOCUSING ON FLORAL BOUQUETS

Flowers are incredibly vibrant and lively subjects, and they are interesting to paint because they allow you to experiment with color. Flowers come in every color imaginable, so feel free to get creative! Consider working in mostly medium and dark values and setting them against a lighter background. This contrast will draw the viewer's eye into your painting. You can also add interest to your painting by using a variety of shapes and sizes—try making some flowers bigger than others. And you can draw the petals facing in different directions—let them droop and sprawl at varying angles. By setting the dramatic warm colors of the flowers themselves against the cool, serene light blue background in this setup, I am able to create a visually exciting composition that breathes life into the painting.

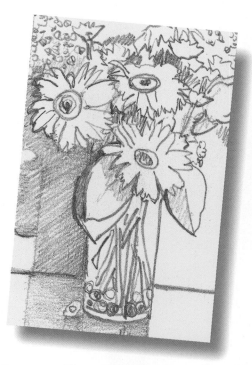

SETTING UP A FLORAL STILL LIFE When arranging a floral still life, try not to overcrowd the flowers in the vase. Use a simple container that won't overpower the flowers, as they should always remain the focal point.

LIGHT BACKGROUND VALUES
Titanium white + cobalt blue

SHADOW VALUES
Ultramarine blue + titanium white + burnt umber

FLOWER STEM MIDTONES
Yellow ochre + chromium oxide green + brilliant yellow-green

FLOWER PETAL MIDTONES
Cadmium orange + titanium white

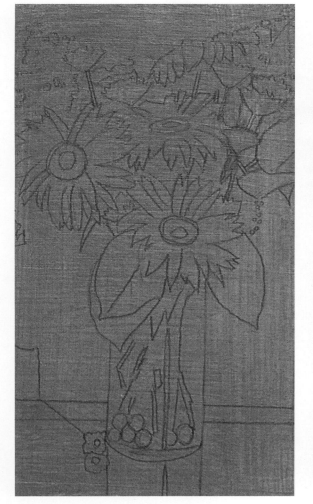

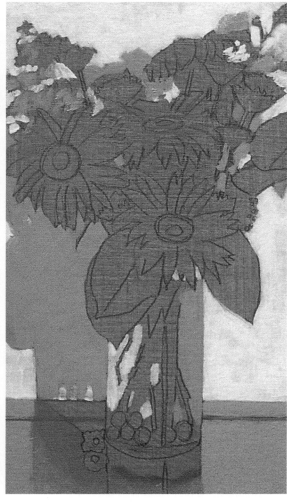

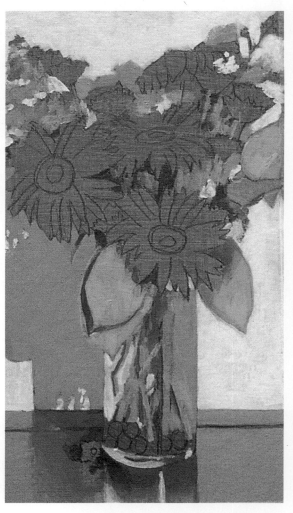

1 I start by painting a diluted wash of ultramarine blue. Then I sketch the floral still life in pencil, being very careful to vary the shapes and sizes of the individual flowers while keeping in mind the shape of the bouquet as a whole. I also sketch the shape of the vase's reflection on the tabletop and the shapes of the flowers' shadows.

2 Next I apply thick layers of titanium white with hints of cobalt blue. With ultramarine blue, burnt umber, and titanium white, I paint the shadow shapes in and around the vase and flowers. I use a medium flat brush to paint the tabletop with a mixture of burnt sienna, yellow ochre, and titanium white.

3 With a blend of yellow ochre and chromium oxide green, I paint the stems of the flowers, working up into the leaves with the same mixture. I quickly dab green around the fallen flower on the table. Then I add streaks of titanium white to the bottom of the vase and the tabletop to suggest its shiny, reflective surface.

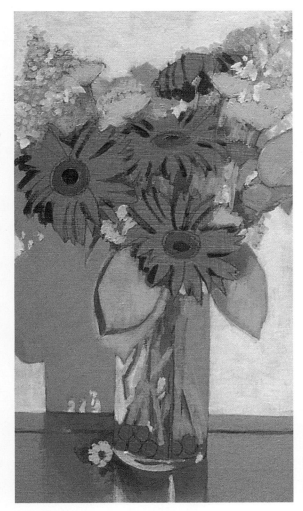

4 Next I begin work on the smaller flowers, using a mixture of yellow ochre, chromium oxide green, and brilliant yellow-green. Then, with a small round brush and a mixture of ultramarine blue, quinacridone crimson, and burnt umber, I create depth by painting the shadows of the darkest petals and their centers.

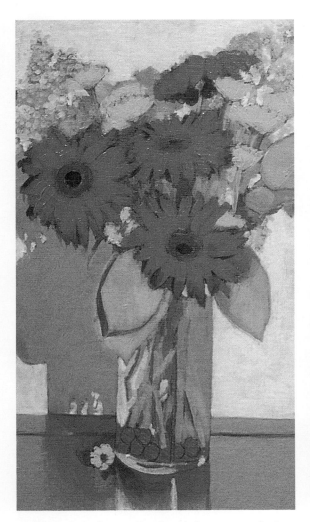

5 For the large flowers, I apply cadmium orange mixed with a little quinacridone crimson and titanium white. I paint following the direction of the petals, stroking downward with my brush toward the tabletop. Then I darken the shadows around the large flowers with my previous mixture of ultramarine blue, quinacridone crimson, and burnt umber.

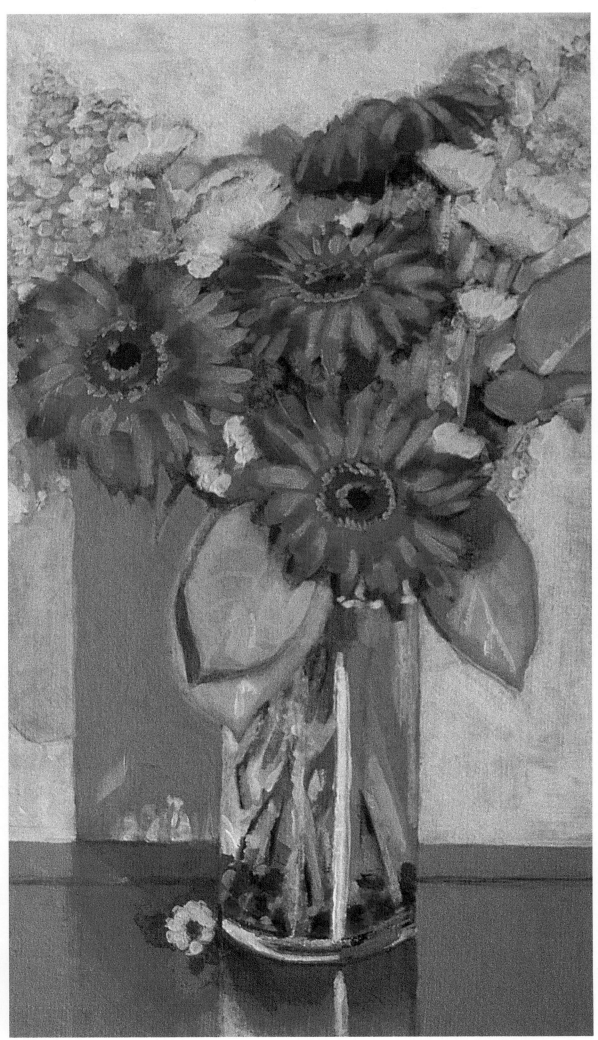

6 Using a medium round brush, I apply light tints of cadmium orange and titanium white to add highlights to the petals. I use bold applications of this lighter mixture and paint in the direction of the petal. I then emphasize the reflective surface of the tabletop by using different values of my previous mixtures of burnt sienna, yellow ochre, and titanium white. I darken the shadows on the table with the darkest values of this mixture. Finally I add highlights with layers of titanium white. My painting is finished when I am pleased with the final composition and the contrast of the warm colored flowers against the cool blue background.

SIMPLIFYING THE SUBJECT

Painting a subject with many elements may seem intimidating, but it's really quite simple and fun to do. Instead of trying to duplicate all the details exactly, paint a rough impression of the overall pattern or shape, and approach the objects in terms of general shapes and masses of lights and darks. By simplifying the elements surrounding the focal point of a painting—such as the wall in the background and the tile in the foreground—you can bring the center of interest into sharper focus. Here the detailed pattern on the bowl and the details of the vegetables are merely suggested, rather than re-created exactly. The pattern of the tiles below the vegetables is also simplified and rounded out, so as to not distract the viewer's eye from the bright, colorful vegetables.

MINIMIZING THE DETAILS In my initial sketch, I establish the main shadows on the tile and the wall. Because these areas are more complex, I want to make sure they are represented accurately from the beginning.

1 Before sketching the composition, I apply a wash of burnt sienna to the canvas. Then I draw the vegetables, using simple lines. I am careful to sketch merely their outlines rather than their details.

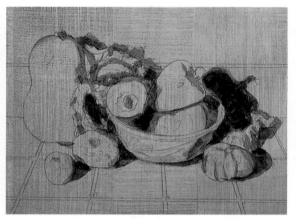

2 Next I block in the dark values of the composition with a mixture of burnt umber and ultramarine blue, building a base for the shadows. I also define the large shape of the bell pepper's cast shadow.

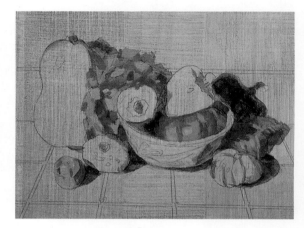

3 Now I mix brilliant yellow-green and chromium oxide green to begin coloring the vegetables. Using bold, expressive strokes and a medium flat brush, I block in the the different greens of the lettuce, bell pepper, and lime.

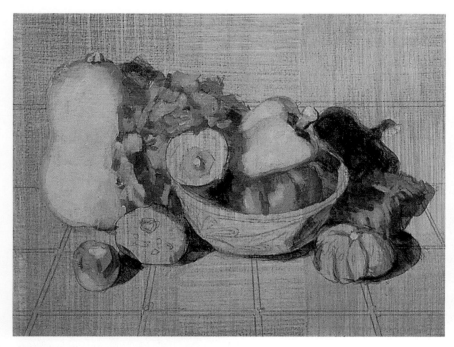

4 Next I use a mixture of cadmium yellow light and titanium buff for the squash, and I mix a combination of cadmium yellow medium and titanium buff for the yellow bell pepper. I then use a diluted mixture of brilliant yellow-green and chromium oxide green to paint the stems of the lime, squash, and bell peppers. I apply quick dots and dashes of color to begin suggesting the details of the vegetables.

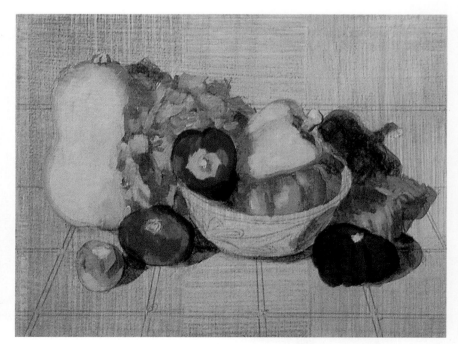

5 Next I paint the tomatoes and red bell pepper, using a medium round brush and mixtures of raw sienna, cadmium red medium, cadmium orange, and quinacridone crimson. I leave the tops of the vegetables unpainted, to suggest their stems. When finished, I add dabs of titanium white to the tops of the vegetables for highlights and to suggest that the light source is coming from above.

20

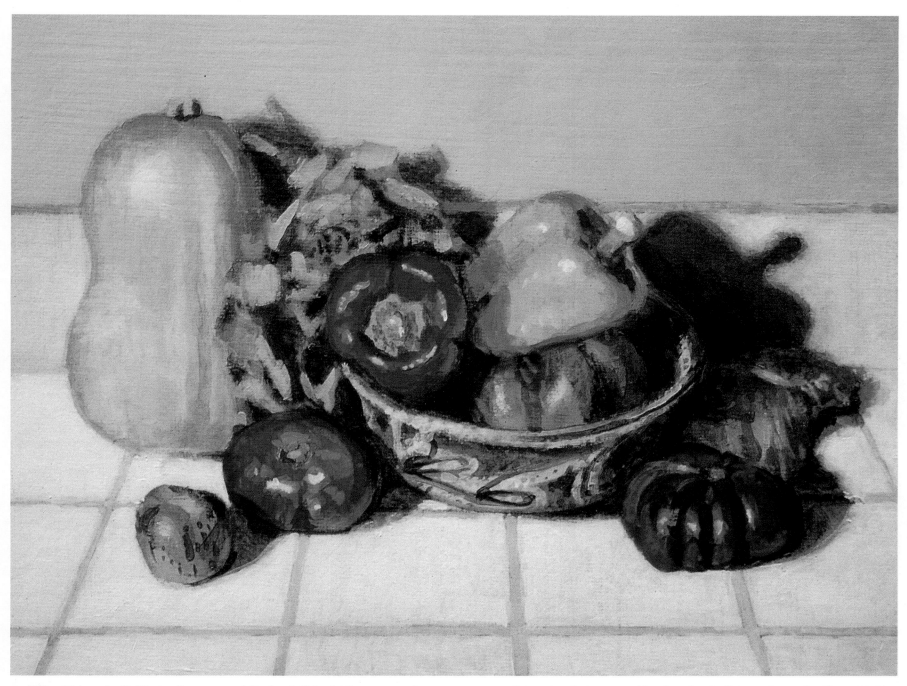

8 With a thick wash of brilliant yellow-green and titanium buff, I paint the upper portion of the background using a large flat brush. With a small brush, I blend dabs of titanium white around the grout of the tiles. I also add small applications of a mixture of titanium white and yellow ochre to sections of the grout, adding some color to the whites. I then saturate all the colors in the composition, boosting the lighter values and pulling out dark areas with touches of burnt sienna. I soften these darker values by rounding out their forms, so that they appear more shadowed. Finally I use a small brush to apply final hints of white to each vegetable to make them look shiny.

6 With raw sienna, I paint the bowl. For the bowl's pattern, I use a small round brush and suggest a few details with swirls of titanium white. I then use a mixture of titanium buff and yellow ochre to paint the grout of the tile and the bottom half of the background. Now I switch to a medium round brush and use darker values of burnt sienna to deepen the shadows of the bell pepper, strongly contrasting the color against the white tile.

7 Next I load up my brush with titanium buff and apply thick, expressive strokes of titanium white and titanium buff to the tile. Using a small brush, I layer the grout with an application of titanium buff, without attempting to duplicate all the details of the tile pattern. When applying paint to the tile, I do not worry about edges or sharpness; instead I think of the composition as a photograph that is just slightly out of focus.

NARROWING THE FOCUS

While the focal point of a painting is always an integral part of a still life, it's usually also just one aspect of the entire arrangement. But sometimes artists do more than make one object a central aspect of a painting; they make it the only element of the painting. When using a photograph as a reference, you can use artist's tape or masking tape to mark off just one area of the setup that you wish to focus on, leaving out the surrounding objects. Another approach is to eliminate any distracting elements from the background of the setup, in order to "zoom in" on the desired subject. In this composition, the background is made blurry and the details of the windowsill are eliminated, while the focal point of the solitary flower remains sharp. The light on the transparent bottle catches the eye, allowing the center of interest to assume the attention it demands.

▶ **CAPTURING THE MOMENT** This painting relies heavily on a source of natural light—I had to photograph the flower before the light changed. When re-creating the scene, I carefully follow the reference photograph to replicate the reflected lights in the shadows and in the lettering on the bottle, but I simplify the background a little by removing the extraneous elements.

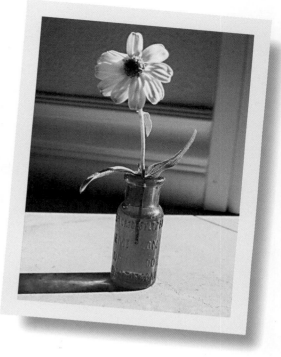

BOTTLE HIGHLIGHTS
Titanium white +
cobalt blue

BOTTLE DARKS
Cobalt blue

BACKGROUND DARKS
Burnt umber +
ultramarine blue

DAISY MIDTONES
Brilliant yellow-green +
cadmium yellow light

DAISY HIGHLIGHTS
Cadmium yellow light +
titanium white

FOREGROUND HIGHLIGHTS
Titanium buff +
titanium white

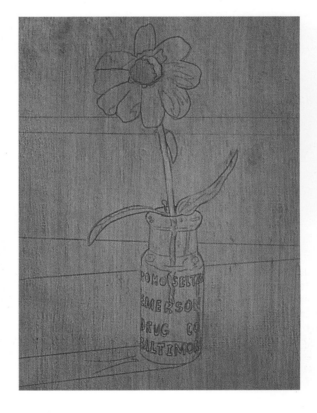

1 After using a large flat brush to evenly tone the canvas with a thin wash of ultramarine blue, I draw the composition. Using a straightedge, I create horizontal, sloping lines to suggest the baseboard and floor shadows. I block in the shadow of the glass bottle and apply lettering so that I'll have a guideline for my applications of paint.

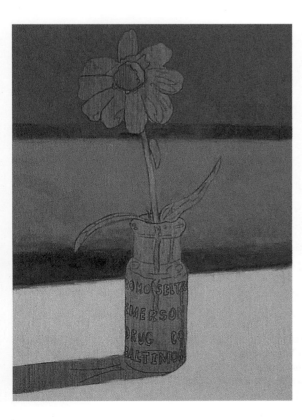

2 Once I am satisfied with the sketch, I use a medium flat brush to block in the foreground with a mixture of titanium buff and titanium white. For the upper half of the background, I mix burnt umber and ultramarine blue, adding titanium white to the mixture for the bottom half. I then create the shadows using a mix of cobalt blue, burnt umber and titanium white, adding retarder to smooth out the transition between colors.

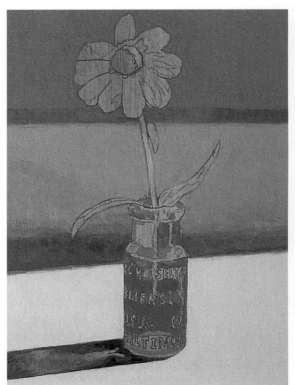

3 Next I build up the cast shadow near the bottle with cobalt blue, mixing in titanium white where I want to suggest that light is shining through the bottle. I then begin work on the bottle itself, using a small brush to apply bold applications of ultramarine blue for the dark values and cobalt blue for the lighter ones. I paint around the lettering on the bottle, around the highlight shapes, and around the stems in the bottle.

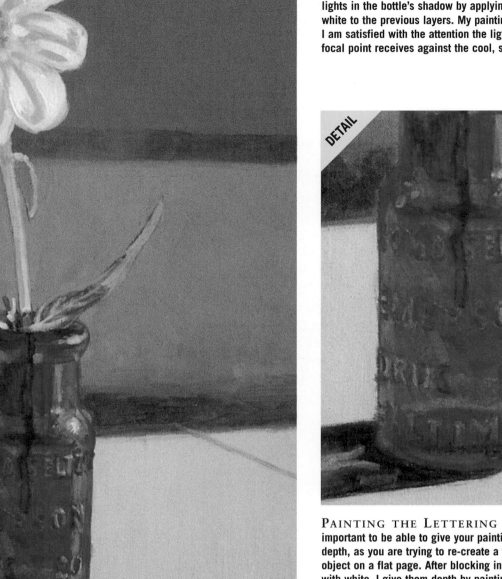

6 Finally I enhance the color of the petals and the highlights in the daisy's center and on the bottle surface using various light mixes of the following colors: titanium white, cadmium yellow light, and ultramarine blue. I apply pink to the daisy's petals using cadmium red medium mixed with titanium white, and I add the final details to the bottle using a small round brush and cobalt blue. I boost the highlights in the bottle's shadow by applying hints of titanium white to the previous layers. My painting is finished when I am satisfied with the attention the light and detail of the focal point receives against the cool, simple background.

DETAIL

PAINTING THE LETTERING As an artist, it is important to be able to give your paintings dimension and depth, as you are trying to re-create a three-dimensional object on a flat page. After blocking in the embossed letters with white, I give them depth by painting dark to light. I start with a detail brush, applying darker values of cobalt blue to outline the letters. Then, once the paint has dried, I lightly dab a mixture of cobalt blue and titanium white over the letters, careful to maintain their general shapes.

4 Using a small round brush, I create the illusion of glass by adding highlights of titanium white to the blue of the bottle. By smoothly blending these white highlights with ultramarine blue and cobalt blue, I give the bottle its translucent quality. Still using the small round brush, I outline areas of the lettering with cobalt blue and ultramarine blue to give them dimension and depth. But I am careful not to add too much detail—I don't want to draw excessive attention to the glass.

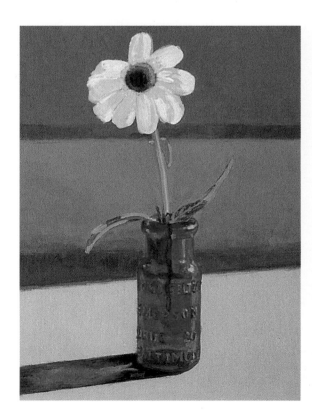

5 Now I paint the stem of the flower using a mixture of brilliant yellow-green and cadmium yellow light. I add hints of ultramarine blue to the shadows on the leaves, and then I paint the daisy's petals using cadmium yellow light mixed with titanium white. With a mix of burnt sienna, quinacridone crimson, burnt umber, and cadmium orange, I create the shadow of the daisy's center. I switch to cadmium yellow medium mixed with cadmium orange and titanium white for the pollen's lightest values.

"FINDING" COMPOSITIONS

Generally artists select and arrange the subjects they want to include in their still life paintings, but many times interesting combinations of shapes, patterns, textures, and colors are happened upon in everyday life. "Found" compositions are ready-made still life setups that are discovered by chance. They can provide an opportunity for study and experimentation, or they may even become your next masterpiece! Try taking a walk through a park or down a residential street; you may be surprised by the potential still life compositions you find. This still life focuses on the intertwining shapes and shadows cast by garden tools propped up against a shed—a composition I found when strolling around my neighborhood.

FINDING THE FOCUS I was instantly drawn to this everyday scene by the intriguing similarities among the disparate tools. While each tool has a very different shape, size, and purpose, the shadows that they cast on the shed were identically slender and vertical.

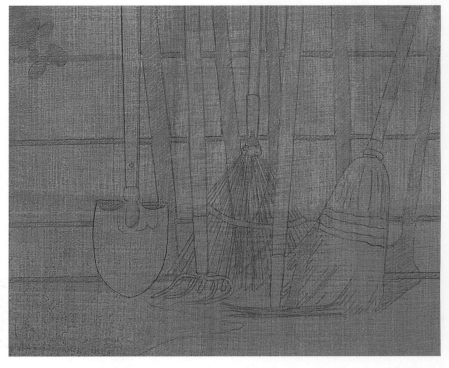

1 First I transfer my sketch to canvas, being careful to try to capture the patterns in the lines of each tool and their shadows, depicting as much detail in the sketch as possible. Then I cover the canvas with a thin wash of burnt sienna.

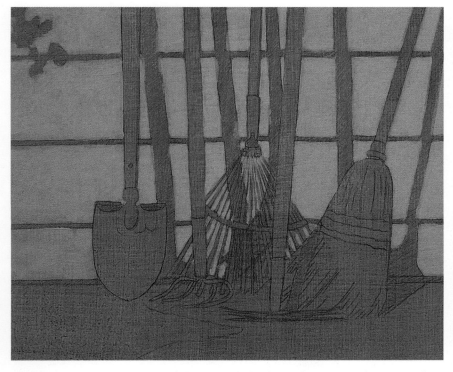

2 I then loosely apply a mixture of titanium buff, titanium white, and cadmium yellow light to the background with a medium flat brush, carefully painting the negative spaces—in this case, the spaces between the garden tools. I leave some areas of the canvas unpainted to represent the shadows cast by the tools and the panels of the shed.

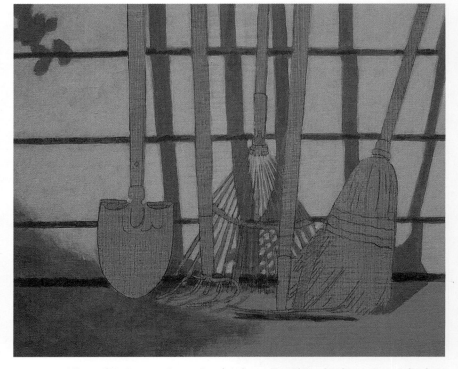

3 Now, adding a little burnt umber to the cadmium yellow light, titanium buff, and titanium white mixture, I paint the cement. I blend burnt umber and ultramarine blue to build up the shadows of the tools, the image of the leaves in the corner, and the darker areas of the shed and cement. Then I use the same mixture for the lines between the shed's panels.

BROOM HIGHLIGHTS
*Titanium buff + cadmium
yellow light*

METAL HIGHLIGHTS
*Titanium buff + burnt sienna
+ cadmium yellow light*

TOOL HANDLE HIGHLIGHTS
*Titanium white + titanium
buff + cadmium yellow light*

TOOL HANDLE MIDTONES
*Titanium white + titanium
buff + cadmium yellow light
+ burnt umber*

TOOL HANDLE GREENS
*Titanium buff + burnt sienna
+ cadmium yellow light +
cobalt blue*

TOOL HANDLE BLUES
*Titanium buff + burnt sienna
+ cadmium yellow light +
cobalt blue + titanium white*

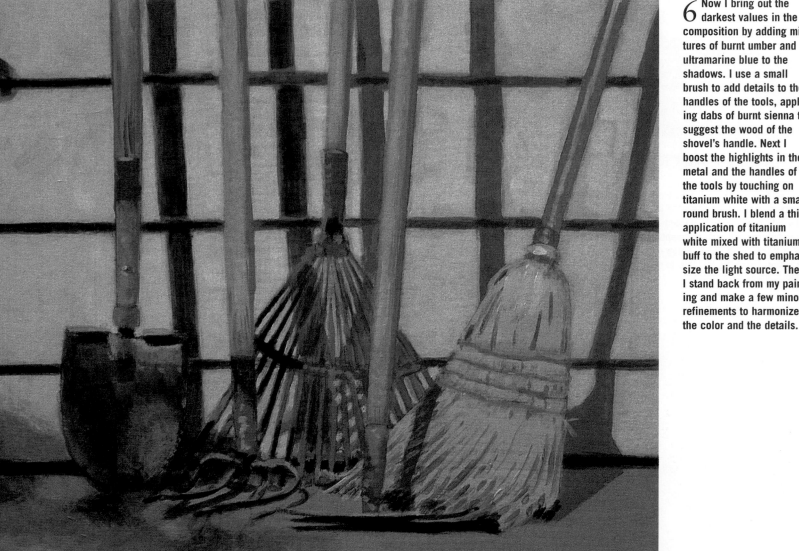

6 Now I bring out the darkest values in the composition by adding mixtures of burnt umber and ultramarine blue to the shadows. I use a small brush to add details to the handles of the tools, applying dabs of burnt sienna to suggest the wood of the shovel's handle. Next I boost the highlights in the metal and the handles of the tools by touching on titanium white with a small round brush. I blend a thin application of titanium white mixed with titanium buff to the shed to emphasize the light source. Then I stand back from my painting and make a few minor refinements to harmonize the color and the details.

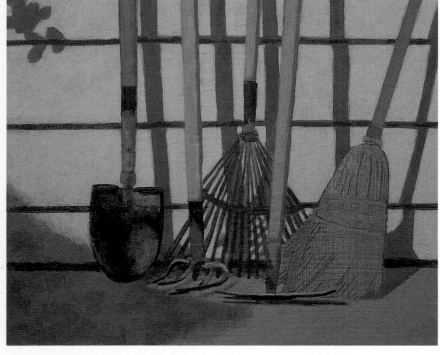

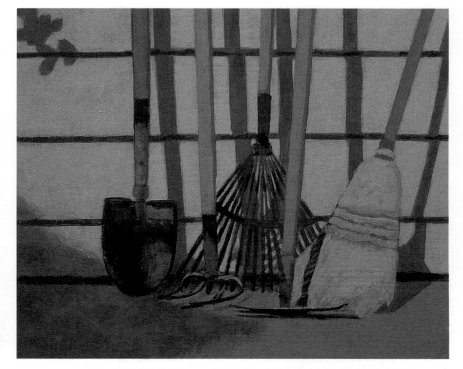

4 To create the illusion of metal, I blend titanium buff, burnt sienna, cadmium yellow light, and cobalt blue, applying the paint with quick brushstrokes. I use different variations of this mixture for each of the tools, adding burnt sienna for rust. I then blend titanium buff, burnt sienna, cadmium yellow light, cobalt blue, and titanium white for the broom's details.

5 Still using a small round brush, I use a mixture of cadmium yellow light and titanium buff to paint the broom. I paint downward with quick brushstrokes to create the broom's brush, being careful to paint around the blue stitching of the broom. Next I deepen the shadows on the rake and broom with variations of burnt umber and burnt sienna.

DEPICTING TEXTURE

Adding texture to a still life painting can be done in several different ways—some special effects are achieved by adding paint, and some by taking away; some require certain artist's materials, such as a painting knife, and some can be done with simple household items, like a toothbrush. You can also depict the texture of an object by varying your brushstrokes: Use smooth brushstrokes for shiny objects and thicker applications of paint for rough surfaces. In this composition, I chose to paint an arrangement of lilies, whose mottled petals have a great deal of texture. In addition to creating the texture of the lilies, I also build up the texture in other areas: Note the coarse, grainy look of the tabletop and the smooth, reflective mahogany of the wooden box. These contrasts allow my subject to leap off the page, making the scene more lifelike and tangible.

USING ARTISTIC LICENSE In this painting, I assert my *artistic license*—the leeway artists are given in their interpretation of a subject—and deviate from the reference to make a unique composition. In the photograph of the still life setup, the tabletop is smooth and reflective. For variation, I give the tabletop in my interpretation a textured, matte surface.

1 I first apply an underpainting of burnt sienna to complement the wood and the seeds. I dilute the paint and tone the canvas with an even application of paint using a large flat brush.

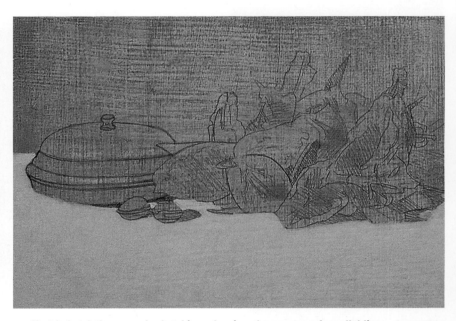

2 Next I sketch the scene by *hatching*—drawing close groups of parallel lines—to create form in the flowers. Using bold strokes, I paint the foreground with a mix of titanium buff and cadmium yellow medium.

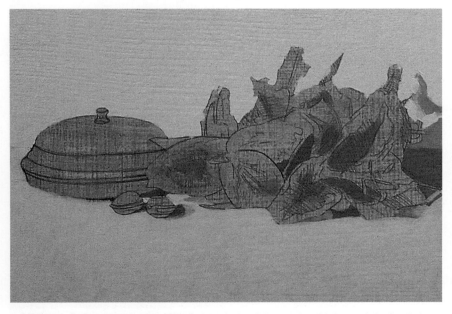

3 Using a medium flat brush, I paint the shadows of the petals with burnt umber and ultramarine blue. Then, using a mixture of titanium white and cobalt blue, I paint a light blue wall above the horizon line with broad, sweeping brushstrokes.

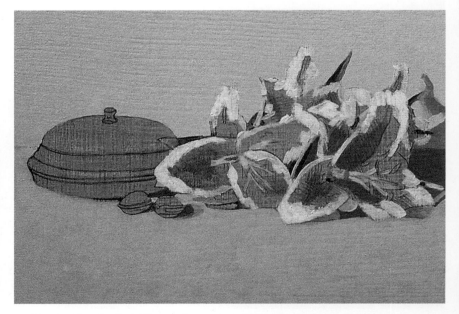

4 I load my brush with brilliant yellow-green to paint the stems and leaves of the flowers, switching to medium green and chromium oxide green for the darkest values. Then, with a small round brush, I apply strokes of titanium white to the outer edges of the petals.

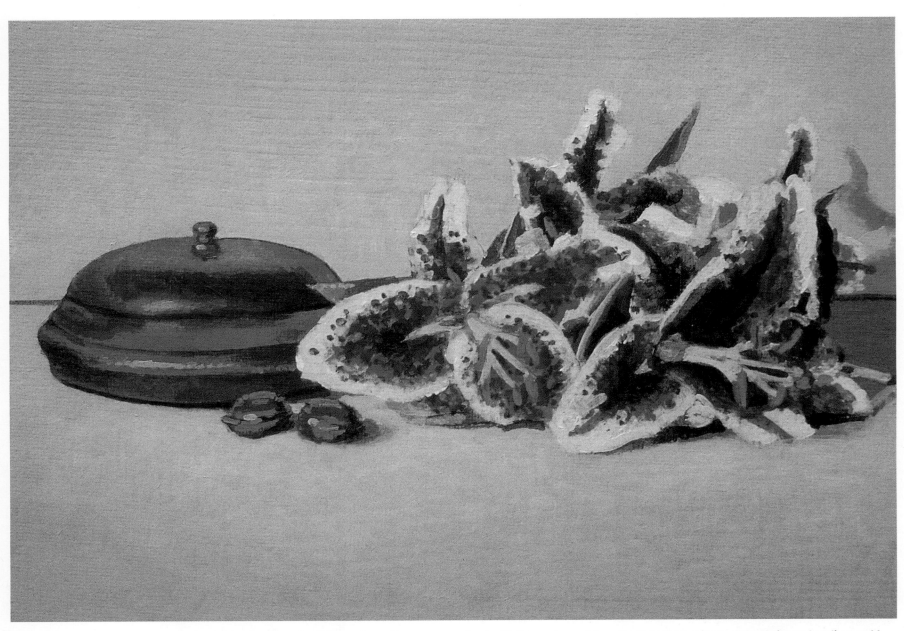

7 I continue to build up the colors in the wood and seeds using lighter values of burnt sienna and hints of cadmium orange. I create highlights by stippling titanium white on the seeds; I then apply long, thin streaks of titanium white to the edges of the box. (This shows that the light is coming from the left.) I add the final touches to the box by painting the knob with brassy tones of burnt sienna, cadmium orange, and titanium white. I load my brush with the previous mixture of quinacridone crimson and cadmium red medium, and I continue stippling the petals until I am satisfied with the way I have brought out the lilies' color. I add titanium white to the mixture for the lighter areas of the petals, and emphasize the darks of the shadowed areas with burnt sienna. Finally I use my detail brush to add the final touches to the flowers and round out the wooden box.

5 Using the stippling technique, I color the petals with a mixture of quinacridone crimson and cadmium red medium. Layering color in the petals helps to give depth and texture to the lilies, making them appear more three-dimensional and closer to the viewer.

6 With a medium round brush, I paint the wooden box and the seeds below it with burnt sienna. Then I apply light strokes of burnt umber for shading, and I use hints of cadmium orange to create the effect of reflection in the wood.

PAINTING OUTDOOR STILL LIFES

Still life paintings don't have to be made up of objects in indoor arrangements; rather, intriguing still life compositions can be created in any outdoor setting! And whether you choose to paint out in the open—which is called painting *en plein air*—or use a photo reference in the comfort of your own studio, outdoor still lifes present you with the opportunity to capture on canvas all the rich colors and inspiring images you find in nature. The beauty and simplicity of a fountain surrounded by foliage or a bird bath standing in a lush garden can be overwhelming—and by portraying this beauty in a still life, you can demonstrate your ability to find charm and allure in a seemingly ordinary setting. In this scene of a birdhouse tucked away in a wooded forest, I take advantage of the natural light source provided by the sun. The light is shining on the roof and right-hand side of the birdhouse, leaving the rest in dark, dramatic shadows and producing a sense of mystery.

1 After applying an even wash of ultramarine blue to the canvas, I sketch the birdhouse and trees. Using a photograph of the scene as a reference, I take my time to re-create the details of the birdhouse. At this stage, I can just loosely sketch the shapes and placement of the leaves, rather than render them exactly. I spend more time on the tree branches, drawing thin parallel lines to represent pine needles.

2 Next I use a medium round brush and a mixture of burnt umber, titanium buff, and ultramarine blue to block in the shapes of the birdhouse shadows and the leaves behind and below it. I don't have to worry about precision when blocking in the shadows of the leaves, as I want the foliage to appear blurry and a little out of focus. I am more careful with the dark areas of the birdhouse, using smooth, steady brushstrokes.

3 Now I begin creating the variations of green for the leaves. For the darkest values of the ivy, I use a mixture of cadmium yellow light and ultramarine blue, blending the paint with titanium white as I apply it to the lighter areas of the ivy. For the pine needles, I use chromium oxide green and brilliant yellow-green, and I apply the paint using quick, thin brushstrokes. I then use small amounts of titanium white to block in the clouds to the left.

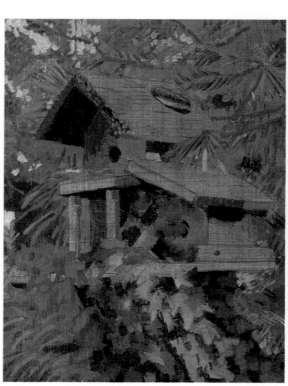

4 I continue to build up the foliage by applying brushstrokes with a small round brush. I make sure that there is a strong contrast between the leaves by using different brushwork for each: quick strokes for the pine needles and longer, sweeping strokes for the ivy. I then stipple titanium white on the areas of the background that can be seen through the trees. Finally I mix burnt sienna and titanium buff to paint the leaves that have fallen on the birdhouse.

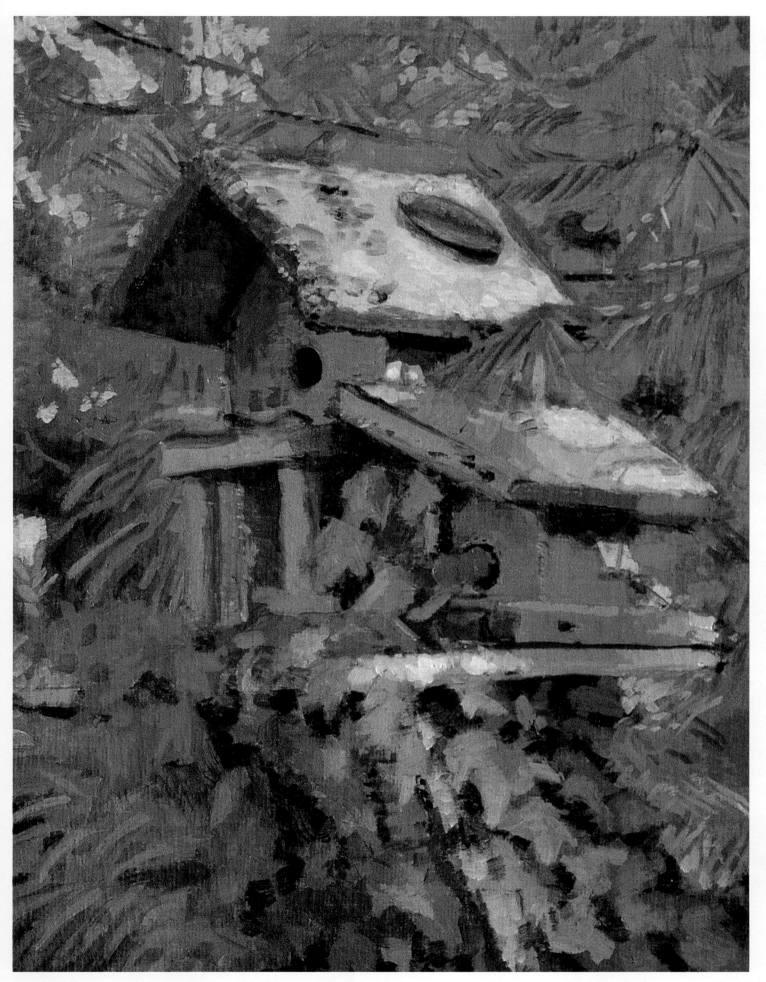

FOLIAGE HIGHLIGHTS
*Brilliant yellow-green +
chromium oxide green*

FOLIAGE MIDTONES
*Brilliant yellow-green +
burnt umber*

FOLIAGE DARKS
*Chromium oxide green +
cobalt blue*

FOLIAGE SHADOWS
*Ultramarine blue + brilliant
yellow-green + chromium
oxide green*

BIRDHOUSE HIGHLIGHTS
*Burnt umber + ultramarine
blue + titanium white +
cadmium yellow light*

BIRDHOUSE MIDTONES
*Burnt umber + ultramarine
blue + titanium white*

SHADOW DARKS
*Burnt umber + ultramarine
blue + titanium buff*

5 Next I block in the colors of the birdhouse, switching to a medium round brush to apply a mixture of burnt umber, ultramarine blue, and titanium white, which will bring out the highlights. I am careful to show that the light is coming from the right by adding the most dramatic highlights and lightest values to the right side of the birdhouse, while darkening the shadows to the left. This high contrast between light and shadow makes the composition more realistic, and it really allows the birdhouse to stand out from its surroundings!

RENDERING REFLECTIVE SURFACES

Metal objects are great subjects for still life paintings because they reflect the shapes and images surrounding them, creating strong contrasts of light and dark and a wide range of vivid colors. Reflections also distort reality and create a somewhat surreal visual. When painting reflective surfaces like metal, it is important to keep in mind that you're actually painting the shadows, the reflections of light, and the colors of the nearby objects. It's also a good idea to try look for the basic shapes and draw only what you see. In this painting, I break down the cooking pot and pepper grinder into simple shapes and values to make it easy to render the colorful reflections and shadows they cast.

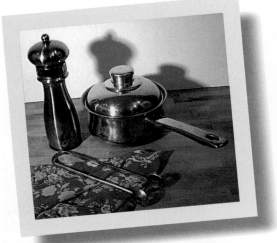

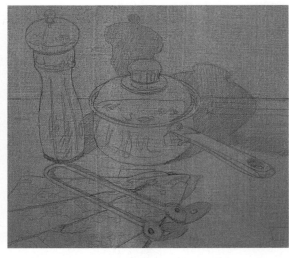

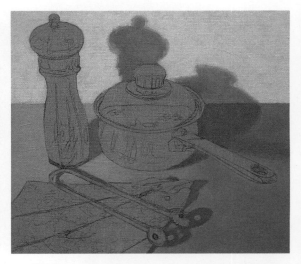

CREATING VISUAL INTEREST When setting up this still life, I placed shiny, reflective metal objects in front of a dark red patterned dishcloth, knowing that the bright colors and shapes in the cloth would stand out in the metal reflection. This creates a lively setup with a lot of visual interest and play of light.

1 First I cover the canvas with a thin coat of burnt sienna. I begin drawing a rough outline of the setup, noting the proportions of the objects and faithfully drawing their different heights. I then block in the shapes of the shadows the objects cast on the wall and tabletop. I also begin to define the areas of reflection in the metal objects.

2 With a mixture of titanium white and titanium buff, I color the background. To paint the tabletop, I use a mix of cadmium yellow medium, ultramarine blue, and titanium buff. I then render the shadows using a mix of burnt umber and ultramarine blue, carefully leaving two small circles in the shadow of the tongs, where the light is shining through.

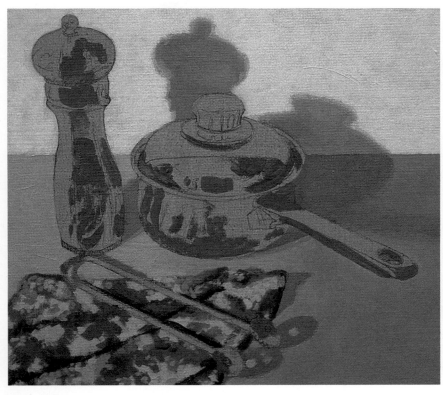

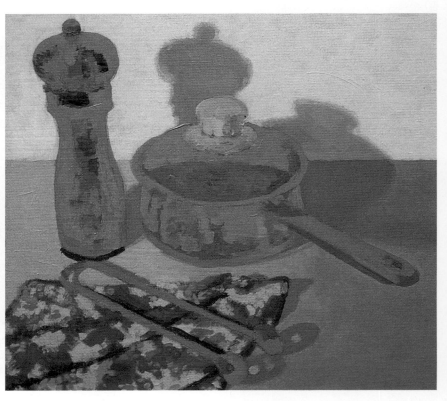

3 Next I develop the dark areas of the metal objects, mixing ultramarine blue with burnt umber. I add patches of cadmium red medium to the pepper grinder and pot to suggest the reflection of the patterned dishcloth. When painting the dishcloth itself, I paint the background of the dishcloth with cadmium red medium, and then I paint the flowers with a mix of titanium buff and cadmium yellow light, adding titanium white to bolster the highlights.

4 Mixing ultramarine blue, burnt umber, and titanium white, I create a foundation for the metal objects. I take great care to paint around the areas of the pot and grinder that have been designated as reflective areas. I then detail the shape of the pepper grinder and the handle of the pot with lighter values of the previous mixture, and I paint the knob on the lid of the pot with cadmium yellow light mixed with titanium white.

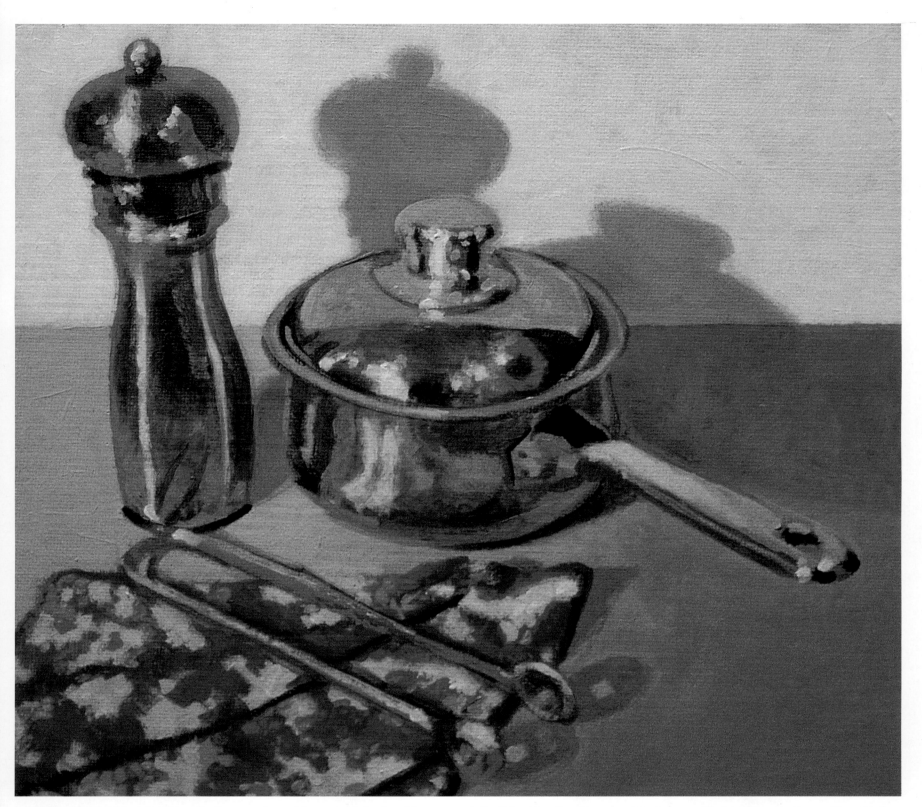

5 Now I add embellishments to the reflective areas by applying more coats of a mixture of ultramarine blue, burnt umber, and titanium white to the surfaces of the pot, pepper grinder, and tongs. I then add patches of titanium white to the areas that I want to sparkle the most, but I am careful not to overpower the darkest areas. Notice that I use titanium white straight from the tube, layering it on top of the foundation mixtures. I add dark values to the lid and handle of the pot and the tongs, emphasizing the reflective qualities of both and making them shine. With a detail brush, I darken the shadow lines cast by the tongs onto the dishcloth using a mixture of burnt umber and ultramarine blue. I then refine the details of the dishcloth, adding touches of titanium white and titanium buff to pull out the lightest values of the floral pattern. Then my painting is finished!

◄ DISTORTING OBJECTS Instead of painting an exact replica of the tongs in the round pepper grinder's reflection, as I would if the tongs were placed in front of a flat mirror, I paint two curved lines that show the distorted reflection. When adding the reflection of the dishcloth to the grinder, I eliminate the details and instead apply splotches of red and white.

METAL DARKS
Burnt umber + ultramarine blue + titanium white

METAL MIDTONES
Ultramarine blue + titanium white + burnt umber

REFLECTION MIDTONES
Ultramarine blue + titanium white

LIGHT BACKGROUND VALUES
Titanium buff + titanium white

SHADOW VALUES
Burnt umber + ultramarine blue

TABLETOP MIDTONES
Titanium buff + ultramarine blue + cadmium yellow medium

DISHCLOTH HIGHLIGHTS
Cadmium yellow medium + titanium white

DISHCLOTH MIDTONES
Cadmium red medium + titanium buff

Walter Foster Art Instruction Program

THREE EASY STEPS TO LEARNING ART

Beginner's Guides are specially written to encourage and motivate aspiring artists. This series introduces the various painting and drawing media—acrylic, oil, pastel, pencil, and watercolor—making it the perfect starting point for beginners. Book One introduces the medium, showing some of its diverse possibilities through beautiful rendered examples and simple explanations, and Book Two instructs with a set of engaging art lessons that follow an easy step-by-step approach.

How to Draw and Paint titles contain progressive visual demonstrations, expert advice, and simple written explanations that assist novice artists through the next stages of learning. In this series, professional artists tap into their experience to walk the reader through the artistic process step by step, from preparation work and preliminary sketches to special techniques and final details. Organized by medium, these books provide insight into an array of subjects.

Artist's Library titles offer both beginning and advanced artists the opportunity to expand their creativity, conquer technical obstacles, and explore new media. Written and illustrated by professional artists, the books in this series are ideal for anyone aspiring to reach a new level of expertise. They'll serve as useful tools that artists of all skill levels can refer to again and again.

Walter Foster products are available at art and craft stores everywhere.
For a full list of Walter Foster's titles, visit our website at www.walterfoster.com
or send $5 for a catalog and a $5-off coupon.

WALTER FOSTER PUBLISHING, INC.
23062 La Cadena Drive
Laguna Hills, California 92653
Main Line 949/380-7510
Toll Free 800/426-0099

www.walterfoster.com